Roughstock Sonnets

1971–1996

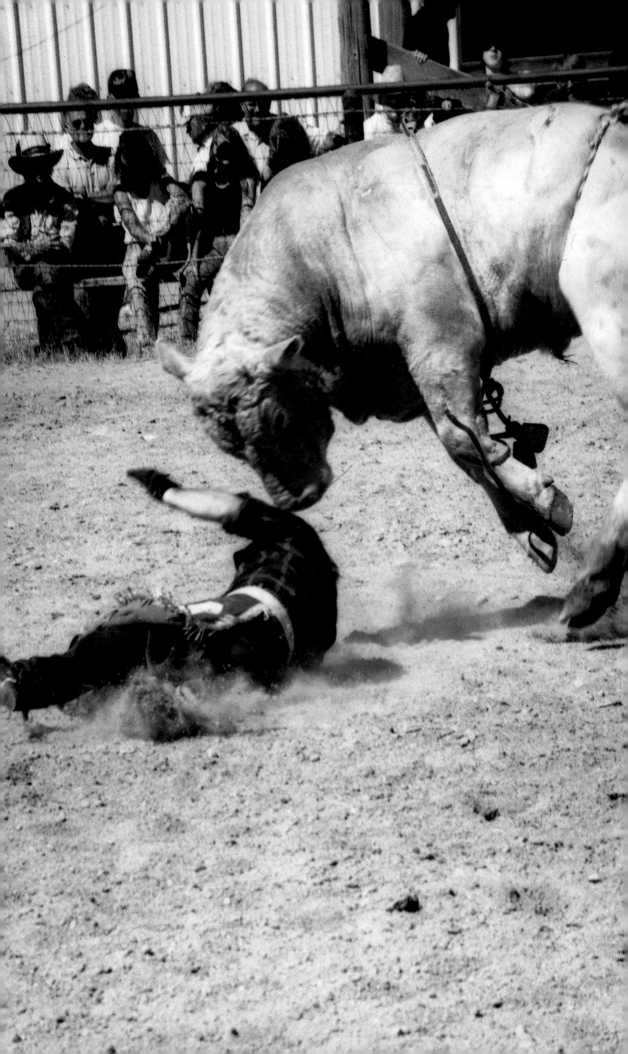

ALL THIS WAY

FOR THE SHORT RIDE

Roughstock Sonnets

1971–1996

Poems by Paul Zarzyski

Photographs by

Barbara Van Cleve

with a Foreword by Teresa Jordan

MUSEUM OF NEW MEXICO PRESS SANTA FE

Dedication

For Shizzers, Red River, Whist, Whiskey Talks, Spitfire, Whispering
Hope, Trill, Othello, Three Bars, Bits, Strawberry, Dolly, Damask,
Spooks, Moonshine . . .

The authors and publisher would like to thank Payson Lowell and the Lowell Press for
giving a number of these works their first "home" in *Roughstock Sonnets* (1989). Also, spe-
cial thanks to John Dofflemyer (Dry Crik Press, P.O. Box 44320, Lemon Cove, CA
93244) for permission to reprint several poems from *I Am Not A Cowboy* (Paul Zarzyski
and Larry Pirnie, 1995)

Project Editor: Mary Wachs
Design and Production: David Skolkin
Manufactured in Korea
10 9 8 7 6 5 4 3 2 1
ISBN: 0–89013–308–5 (PB)
ISBN: 0–89013–312–3 (CB)

Library of Congress Cataloging-in-Publication Data is available

MUSEUM OF NEW MEXICO PRESS
Post Office Box 2087
Santa Fe, New Mexico 87504

Contents

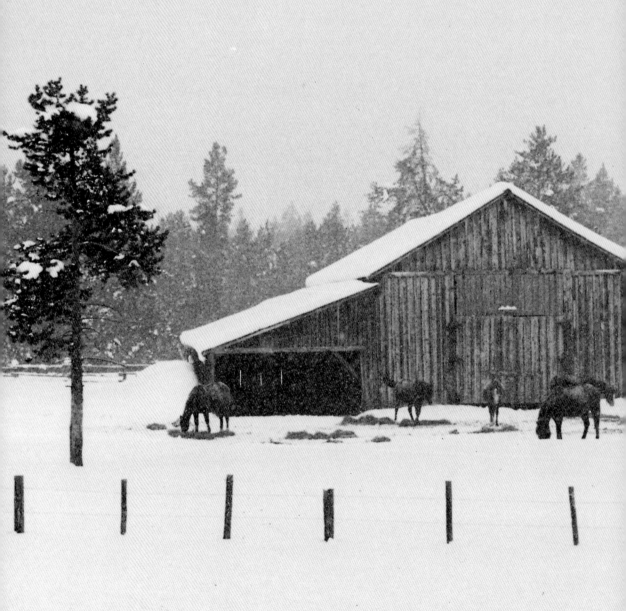

Foreword

I hadn't known Paul Zarzyski very long when I gave him an inappropriate gift. It was the mid–1980s, and I had become enamored with the music of George Winston. I could listen to his moody piano pieces over and over, almost like a mantra, and I thought I was doing Paul a favor when I gave him a couple of Winston's albums. The next time I saw him, I asked what he thought. He grumbled something about yuppie Musak, and then he came down to the crux of it. He focused so intensely when he wrote, he said, that when he broke out of that interior world and listened to music, the last thing he wanted was something soothing and mild. He wanted hard rock and blues, something like George Thorogood's "Bad to the Bone."

Bronc riders dream of being "tapped." In the ultimate ride, every iota of wildness and fire that is horse explodes to be matched, leap by plunge and spark by flare, with the body and soul of the rider. This is the bliss of mortal transcendence, for man becomes horse and horse becomes man, churning sweat and thunder, dust and lightning into beauty. For eight seconds, horse and rider tap into some impossible excellence and know each other better than two minds can. At the core is an almost feminine tenderness. Call it intuition. And afterwards — afterwards — release comes with an unfettered gallop and kick, and a lot of brassy honkeytonking. Bad to the bone.

What would Paul Zarzyski have done if his soul hadn't been kidnapped by rodeo and similarly stolen by poetry? What better metaphor than a bronc to carry the intensity with which he lives the language? Poems and broncs are crucibles where a lifetime of yearning and passion distill into something pure. Eight seconds or twenty lines: the great rides, like the great poems, take a lifetime to create and are both ephemeral and lasting, shimmering like some eternal afterimage of sacrifice and desire on the edges of consciousness. They strike sparks off the wild soul we each still have within us and make us believe, once again, in the impossible.

A few years ago—not so long after I'd gotten to know Paul—I had the chance to spend several hours interviewing Phillipe Petit, the high-wire walker who had come to international attention for his unauthorized walk between the towers at the World Trade Center in New York. An intense man who had devoted his life to the twin passions of beauty and danger, Petit immediately reminded me of Zarzyski. He told me that in the old days, before cable replaced rope, high-wire walkers worked barefoot, and that the marks of their trade, invisible so high up in the air, were the parallel lines of callus on the bottom of each foot that became, over years of practice, as hard as horn or bone. These calluses caressed the rope and, when the wire walker came back to earth, he could feel them between himself and the ground, a constant reminder that he owned the air.

The most deeply lived passions shape us in invisible and not-so-invisible ways. Broncs have rearranged Zarzyski's anatomy—nothing major, but you can catch it in his walk, especially on a cold day, and his right arm is a few centimeters longer than his left. Bad to the bone, you might say. And poetry? Maybe its mark is

that acrobatic tongue, miraculously at ease on a language stretched tight and resonant above a dangerous abyss. Not music exactly. Certainly not George Winston. But something full of dance and devilment. Something good to the soul.

Enter Barbara Van Cleve. Chronologically, she and Paul are of a different generation. Spiritually, they're more like twins. Barbara wears the marks of her own passions and experience, a stiff-hipped walk earned by decades of Montana winters a-horseback, and the aches and pains of one who has carried a lot of heavy photographic equipment a good many miles.

Barbara's father, Spike Van Cleve, was a renowned storyteller, and Barbara can craft a pretty good tale herself. But perhaps it was the art of listening, honed early, that most shaped her visual expression, for hers are images that start with knowing the subject from the inside out. In the West at large and rodeo in particular, any good photographer can catch flash and grandeur. Barbara captures something more, which is authenticity, the deep and lasting story within the transitory moment rendered on film. Hers are strangely verbal photographs, full, in some inexplicable way, with language, which is what makes them pair up so magically, so mystically, with Zarzyski's poems.

A few years back, the scholar John Briggs introduced me to a twenty-dollar word that has changed forever the way I look at art: "omnivalence." If ambivalence is a middle-of-the-road, neither/nor proposition, omnivalence is that quality of *more* that resonates from lasting work. The Mona Lisa has an omnivalent smile, filled with more than we can quite articulate: it is sensuous *and* virginal, innocent and knowing, cynical *and* sincere. The first line of Hemingway's story "In Another Country" similarly rings with omnivalence: "In the fall the war was always there, but we did not go to it anymore." Wistful, cynical, relieved, despairing: we can't get to the bottom of it, and while we can't fully describe it, we can't forget it either.

Either Van Cleve's or Zarzyski's work, taken alone, has an omnivalent quality. Dovetailed side by side, the effect can be downright electrifying, as in the title poem, "All This Way for the Short Ride," inspired by the death of Zarzyski's rodeo compadre, Joe Lear. A poem commemorating death, the images are those of fertility and birth as the bullrider's pregnant wife comes stunned into the arena to pick up "her husband's bullrope and hat, bells/clanking to the murmur of crowd/ and siren's mewl." The images throughout are fetal and infant: that mewl; the poet, a bronc rider, imagining even as he mourns his friend what he wants for his own upcoming burst from the chute, "details of a classic ride—body curled/fetal to the riggin'. . . "; the baby inside the wife's belly fighting "with his mother for air/and hope . . . ," learning "early/through pain the amnion could not protect him from . . . the sheer/peril of living with a passion/that shatters all at once" The images circle back to the poet's own passion, to that which simmers like intoxication, aware of possible futures and riding in spite of (and also because of) them, "flesh and destiny up/for grabs, a bride's bouquet/pitched blind." The poem leaves us trembling with loss and exhilaration, futility and earned greatness, blind lust and exquisite tenderness. In Van Cleve's photograph juxtaposed beside the poem, a bronc rider leans so far back as to be almost exploded by the ride, wide open in his vulnerability and also his grace, his position so extreme we aren't sure if he is purely tapped or already over the edge.

All This Way for the Short Ride cuts to the bone and reaches the marrow of pure meaning: the good of things, the bad of things, the interior world where good and bad can't begin to describe things. This book is about rodeo. This book is about life. It will last.

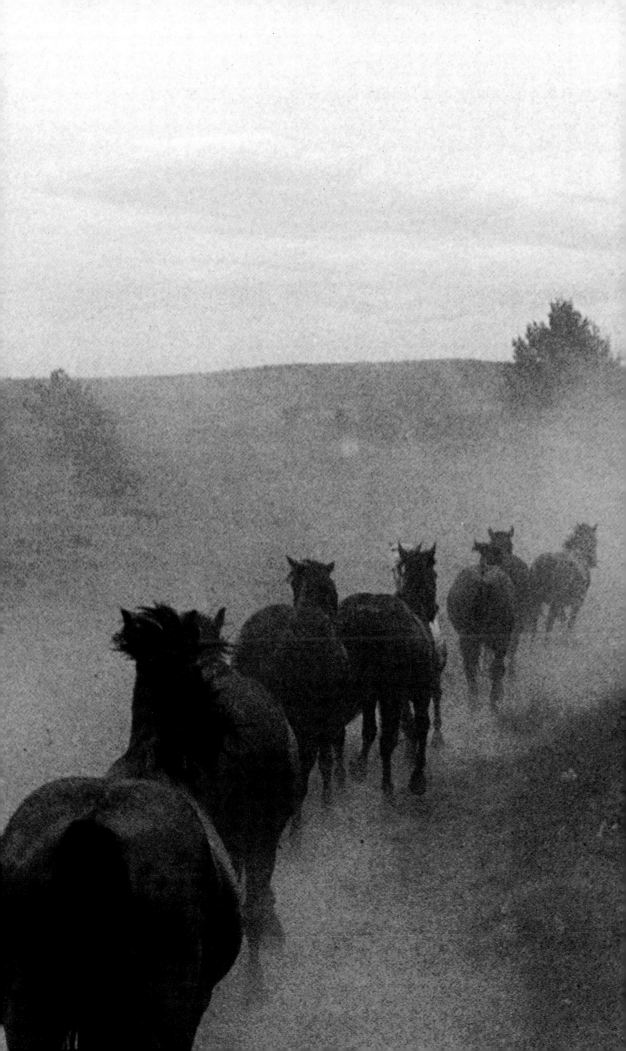

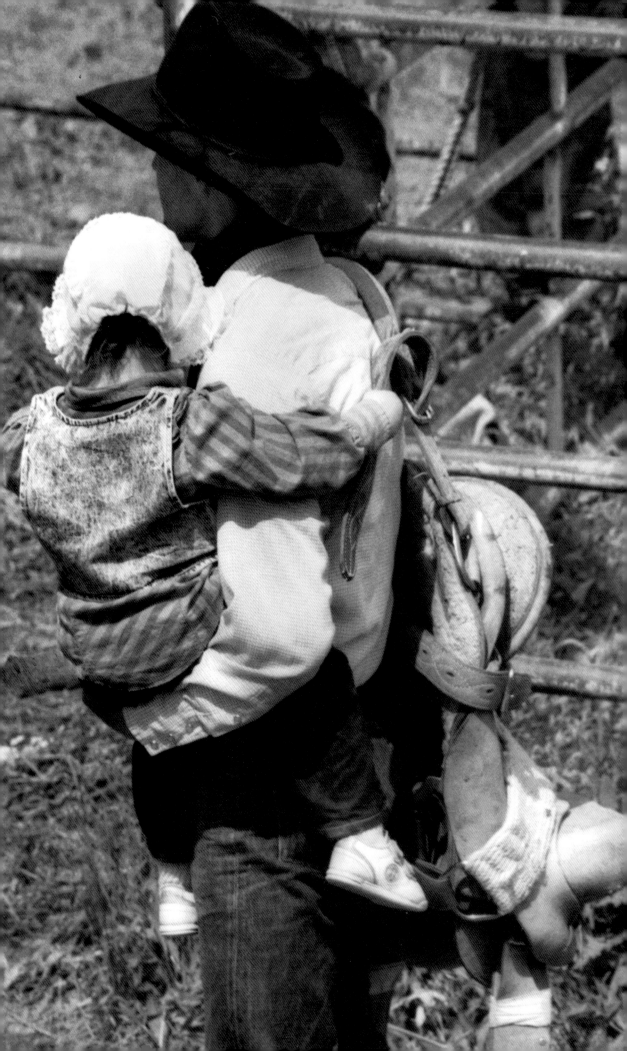

Ain't No Life after Rodeo

or

The Polish–Hobo–Rodeo–Poet's Commencement Address—To the Chagrin of Every Graduate's Mother—At the College of Buckaroo Knowledge

There ain't no life after rodeo
Sulled-up old cowboys will tell you so

So when you feel your spur-lick weaken
And your bareback riggin' goes to leakin'

Bury your gripper elbow-deep
To hell with looking before you leap!

Fight for those holts, sight down that mane
Spit in the face of age and pain

Give that hammerhead a hardware bath
Dazzle the judges with 90s math

Spur the rivets off your Wranglers
A cappella rowels don't need *danglers*

Rake like a maniac, tick for tick
Tip your Resistol, flick the crowd's Bic

Fast-feet-fast-feet, gas-it-and-mash
Toes turned out with each jab and slash

Insanity, love, plus aggression
Call it passion, call it obsession

Adrenalined fury, 200 proof
Like guzzling moonshine up on the roof

Running on Bute, LeDoux songs and caffeine
You rollicking, rosined-up, spurring machine

Too lazy to work, too scared to steal
Slaving for wages bushwhacks your zeal

So charge that front-end for those 8
You ain't no rodeo reprobate!

Grit each stroke out with every tooth
You're swimming the cow*boy* fountain of youth

Love that sunfish and love that high-dive
Believe you will ride 'til you're 95.

FOR WAYNE BRONSON, TRACY MIKES, JERRY VALDEZ, TED KIMZEY, BOB BURKHART,
BILL LARSEN, DEL NOSE, DEB GREENOUGH . . .

Benny Reynolds' Bareback Riggin'

A bacon slab a-boiled black in oil every day
Ain't as soggy as the surcingle he folds whatever twisted way

He wants to, heck it always has sprung back,
Like a flapping magic bird pulled from his riggin' sack

Pre-rosined and fit directly to the withers of a bare
As if slipping on his socks, there's never any scare

In his wrinkleless face—those are laugh lines!—
And no matter what he draws, he never frets or whines

Or paces, he just climbs aboard and shakes his face
And takes to raking like he's in a race

To stay one big lick ahead of old-man time
Who can't figure any reason, can't savvy any rhyme

To the way this rodeo-arena George Burns
Keeps on smoking 'em, how he never learns

That he's older than petrified dinosaur poop—
Did he *cowboy?* or did he *caveman?* with Alley Oop

Back when he and glaciers together first cracked out
In the Mesozoic era when stock was Flintstone stout

When you had to strap a muzzle on Tyrannosaurus Rex
Or you'd lose a leg or two, and talk about your wrecks!

Those pile-driving reptiles hit the ground with force
And mass a thousand times that of a feathered horse

Bounced a fan from front row to a nose-bleed seat
You had to get your holts, you had to use your feet

Whether you was entered-up or you was there to watch
Benny Reynolds setting this same riggin' in the scaly notch

Between the first and second spik-ed dorsal fin
Of some big ol' thorny lizard he spurred hard enough to win

Just like he does today, with lots of rapid gap,
Those dinos had some girth so you damn sure had to tap

Off on that first squalling hop, or good-bye screws
That snub your riggin' handhold to its body, and you'd lose

Your gripper, and get back-doored and likely whaled,
A shuttlecock badmintoned by a thrashing three-ton tail

Which is why, I'll bet, three wraps of rusty baling wire
Is what's holding Benny's handhold on, I could inquire

But I hate to seem a greenhorn, wet behind the ears
Regardless of the umpteen hundred dozen years,

Or eons, that separate our riding gear and style
Of psyching-up—I'm a nervous wreck, Benny's one big smile!

And once I even seen him place a snoosey, juicy smooch
Upon the cheek of Kesler's pick-up man, not even hooch

Could loosen me enough for such flamboyant flare and flirt—
Besides, I mostly pick myself up, I mostly kiss the dirt.

But why? My riggin's up to date with each space-age part
Tailor-made, fit-to-form, state-of-the-art

High-tech precision, the bareback Cadillac of rigs
Aerodynamically perfected like the Rooskys build their MiGs

Not prehistoric pterodactyls, the only thing that flew
Awkward as a tailless kite, back when Benny's rig was new!

It's time to shed some light upon this riddle I've got spun
I'll rub the maker's stamp with spit and tilt it toward the sun

I swear it won't surprise me, I'm ready to believe
It's built at Adam's Saddlery from snakehide tanned by Eve.

FOR BENNY & RONNIE ROSSEN

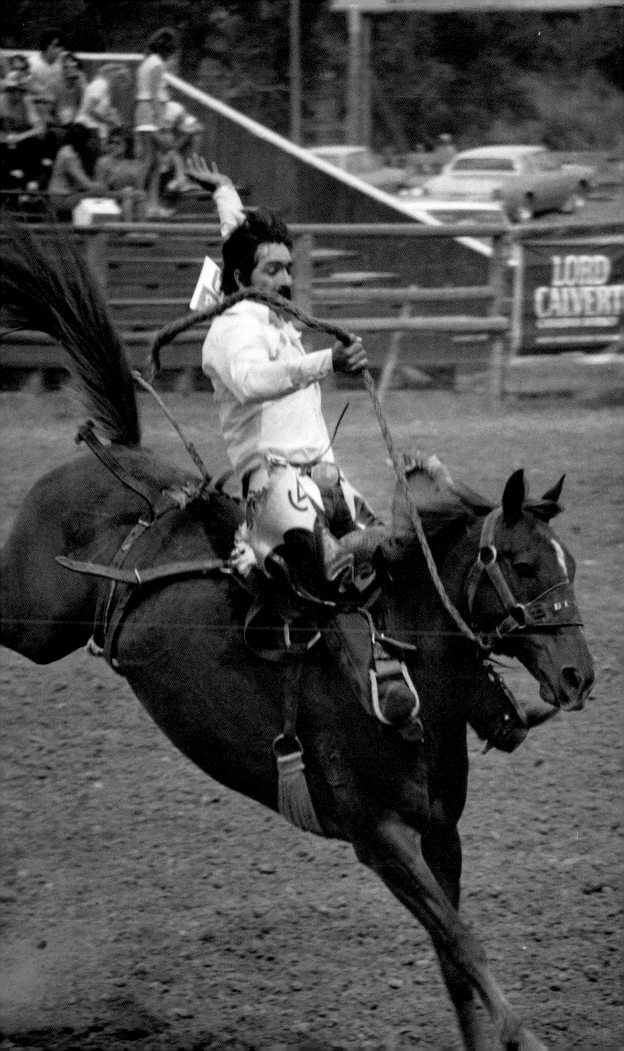

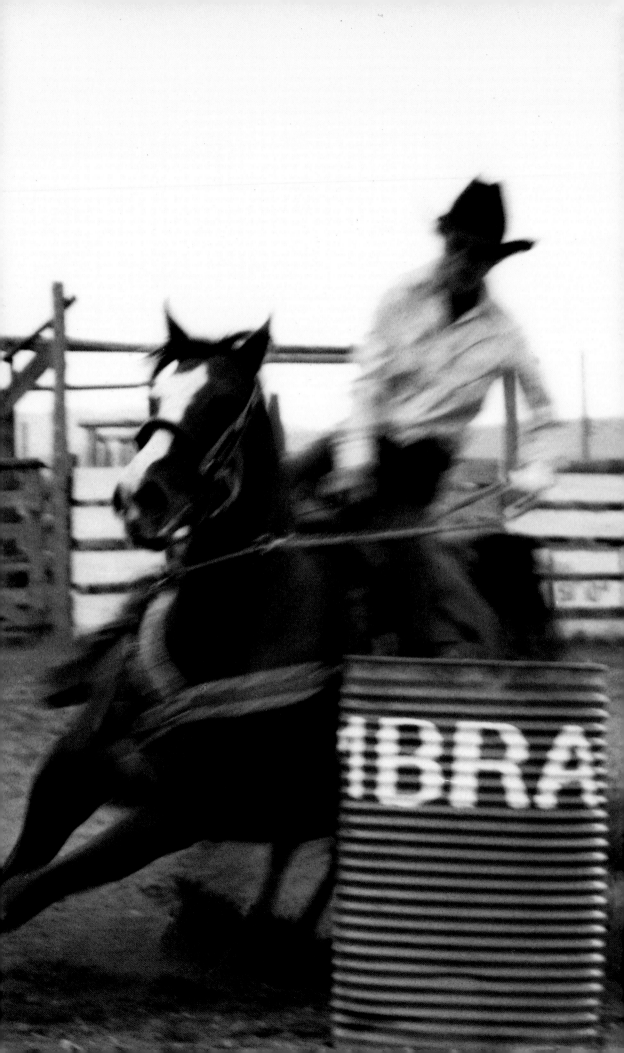

Hip-Cocked Broncs

Through gates pivoting like pinball flippers,
through mazeworks of alleyways
and cutting quick 90s
into the catchpens, snorty horses are sorted
early, before full-bore July 4th sun, already
white-hot as a cinch ring
in the campfire of an early cowhand
out gathering slicks. Wet saddle pads
pressed thin, our flat waistlines fold
over the top lodgepole pine rails. We lean to read
the line-up of branded hips
for numbers posted beside names
on the draw sheet, *8 A.M. slack*
nailed beneath the crow's-nest. The grandstand
writhes with fans rousing to nightmare
hangovers in hot nylon bags
beginning to steam sour
while the hip-cocked broncs—steeped in the sweet
grass incense of their own scent, a light
dew misting off their backs—loll in dreams
before our 8-second shifts. Maybe
they twitch for the winning
every bit as real as we do
behind the chutes, slashing air with a whip-
crack of fringed batwings and rowels ticking
as we pace off maniacal rides
wild in our minds. We nod our heads
determined to spur pretty and win
our gypsy way to the next pitchin',
to another arena's rank bucker and buzzer,
Klaxon, welcome whistle, bell sounding
today oddly reminiscent
of that ricochet blare off lockers
years back in high school halls
between classes. I think I savvy now,
finally, the secret meaning

echoed by your 8-line poem
failing me so often
Mister Cody Bill Carlos Williams:

So much depends	So much depends
upon	upon
a red wheel	a red roan
barrow	bronco
glazed with rain	named The Grim
water	Reaper
beside the white	beside the word
chickens.	Zarzyski

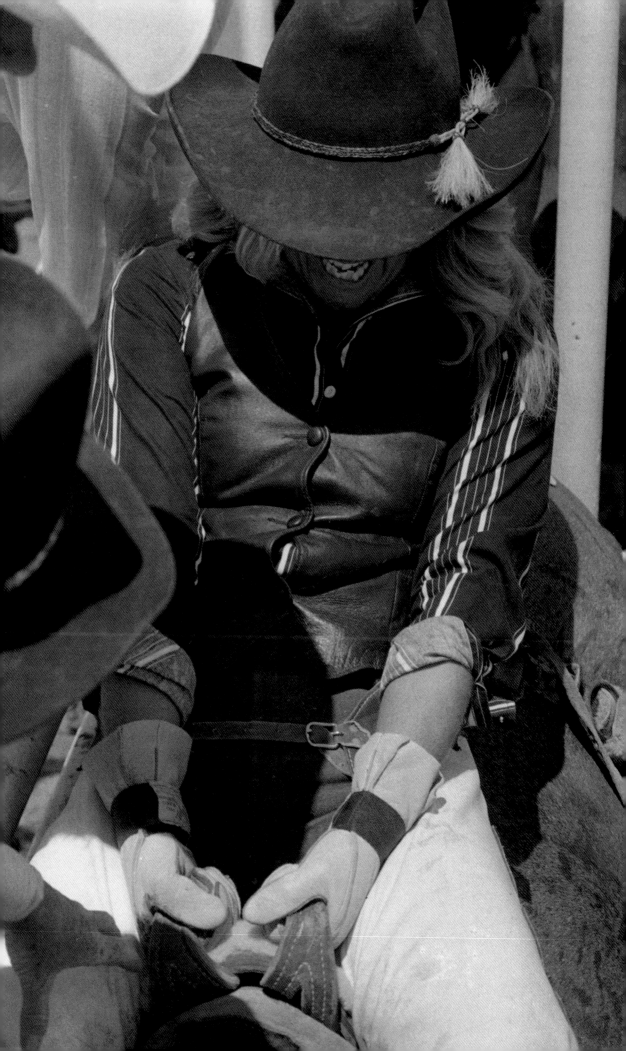

How the Lord Throwed-in with Mom to Make Me Quit the Broncs

Please don't tell my mother
I'm a rodeo cowboy. She thinks I play
piano at the whorehouse in Wallace, Idaho.

Was my mother sayin' rosaries day and night
—beads coiled 'round each mitt—
that compelled the Lord to heed her prayers,
if He built this world in seven days
He could dang sure make me quit.

So first God hires on this angel,
a thief, a rustler, 'fore he come reborn,
to filch my warbag from the pickup cab—
no gear, too broke to buy it new, God thought,
that'll ear him down and leave him shorn.

Now I got no insurance on my life,
my health, my house, or half-ton Ford,
so when State Farm rushed that check
—full coverage for my losses—
you might say, it *surprised* the Lord!

Inside a week, I'm back a-scratchin'
with riggin', hooks, rosin, chaps, and glove,
while God, studyin' hard his notes
on Rodeo—"How to break an addict"—
concocts plan B there up above.

I'll hang him up, He figures, *spook him good,*
have Kesler's Three Bars stomp his lights,
pop his stubborn pumpkin off arena posts
'til he's floppin' like a neck-wrung chicken—
that'll squelch his fight!

Now spurrin' bares is a bunch of fun
when yer gettin' holts and packin' extra luck,
but when yer hung, yer riggin's slipped,
and yer downstairs, it's a lot like slapshot—
hockey—yer noggin plays the puck.

That mare rag-dolled me 'round the 'rena
left me caked with lather, blood, and dirt,
and yeah, I took some stitchin' up,
but even worse, my ridin' arm's much longer now—
it's a bitch to tailor me a shirt!

I'll hand it to the Lord on this one,
He come close to sourin' me for good,
but "close" don't count for nothin'
'cept in pitchin' hand grenades and horseshoes—
next day, I enters every rodeo I could.

When plans C thru V don't work no better
and the Almighty's runnin' shy of rope,
He savvies *W,* for Woman, *I'll make*
that twister fall so hard in love and lust . . .
she'd make me hang 'em up, He hoped!

Oh, she was the prettiest filly God give teeth
—next to her, Bo Derek scored a 2—
and I quit everything she asked,
from snoose to hooch to cussin' rank,
but no, not buckers, no matter how she'd coo.

So finally mom stopped prayin', and God's relieved
cuz He run out of plans with Z,
ol' Three Bars, she's retired, my gal's run off,
and you know, I'll be go-to-hell
if everyone ain't up and quit, but me!

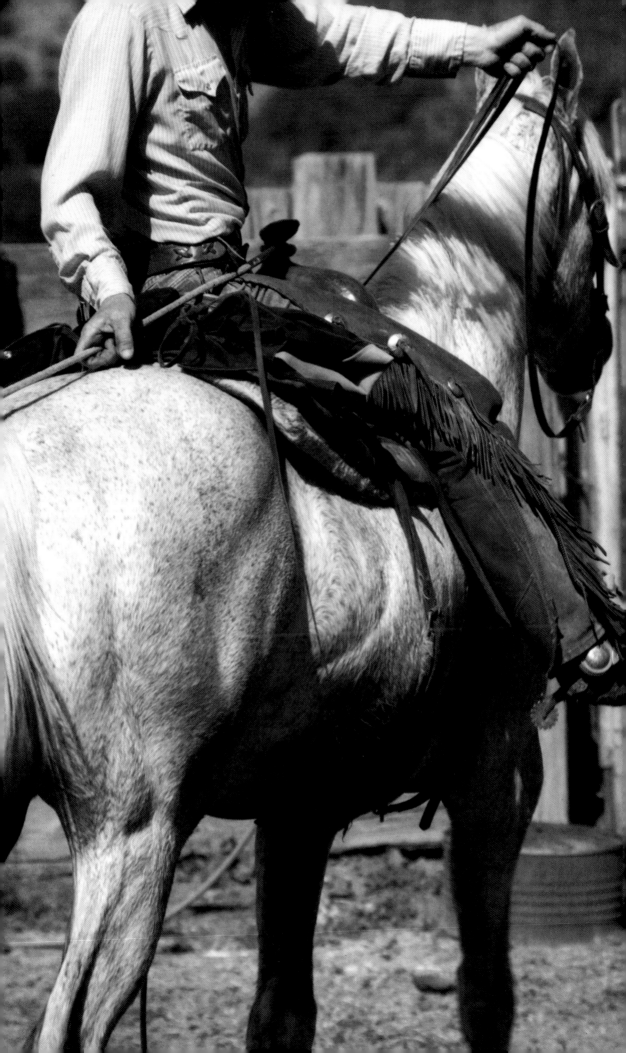

Rosined-Up-'n'-Itchin'-to-Git

He nods for the chutegate,
fudge plug in his cheek,
with his flat noodle riggin'
(barn-auction antique).
His heart's a steel cup
raked 'cross his ribs
as he craves 'em like Murray,
Mahan, and Tibbs.

Just a 50 pound kid
on an 80 pound bale,
arena dust swirling
in his spur-clicking gale,
an 8-second twister,
a 90-point ride,
his mind in the middle,
one leg on each side.

Red mane from Mom's hairbrush
strawberries each rowel,
his riggin' pad's Cannon,
her king-size bath towel.
The puff that she uses
to powder her nose
sure slicks-up the pull
of his dry latigos.

His bedroom is postered
with roughstockin' champs,
there's bull-rider curtains
and bronc-peeler lamps.
With Midnight and Moonshine
Super-glued to the ceiling,
in his hoss-buckin' dreams
he hears buckin' hoss squealing.

Old "Rodeo Sport News"
shingle his bed,
jump-'n'-kick pictures
he's read and *re*read.
Ian Tyson, Red Steagall,
McMahan and LeDoux
sing him rhymes you might call
"Mother Goose Buckaroo."

His hat on one bedpost,
his chaps on another,
a new rosin sock
but don't tell his mother.
Cuz she can't find the mate
to the red strip-ed one,
the whitest of whites
on the line in the sun.

The new minister's dog,
a Saint Bernard cross,
drools like a bull
but he'll pass for a hawse.
He's 10 kid hands high—
counting fur, maybe taller—
and a keg of ol' redeye
hangs from his collar.

On Purina-fed Shep,
he's Butch, the train robber,
'nother tough get-away
you can tell by the slobber
that lacquers his Acmes
and lathers his jeans,
but nothin' Dove soap
and the dishrag won't clean.

He tallies-up weekends
'til the Blaine County Fair,
where he'll ride every critter
with fur, fleece, or hair.

He's the top mutton-buster
two years in a row,
he'll win Little Britches
then prob'bly go Pro.

There's a girl in his class
with blond bronc-rein braids,
a cute little filly,
though she gets too-good grades.
But she's got a guy's name—
his *new* best friend's Toni—
and awesomer yet
she's got her own pony.

In his after-school chores
on a cowboyin' quest,
he nighthawks for wages,
cuz this wolf of the West
will need a good riggin',
some star-spangled chaps,
and monogrammed spurs
with basket-stamped straps.

A new day, a fresh bale,
more NFR rounds,
his blue heeler yelping
the same raucous sounds
as the Tom-Mack Arena
bursting with cheers
to a gold-buckle ride
he'll make in 10 years.

FOR CAIN THOMAS EATON

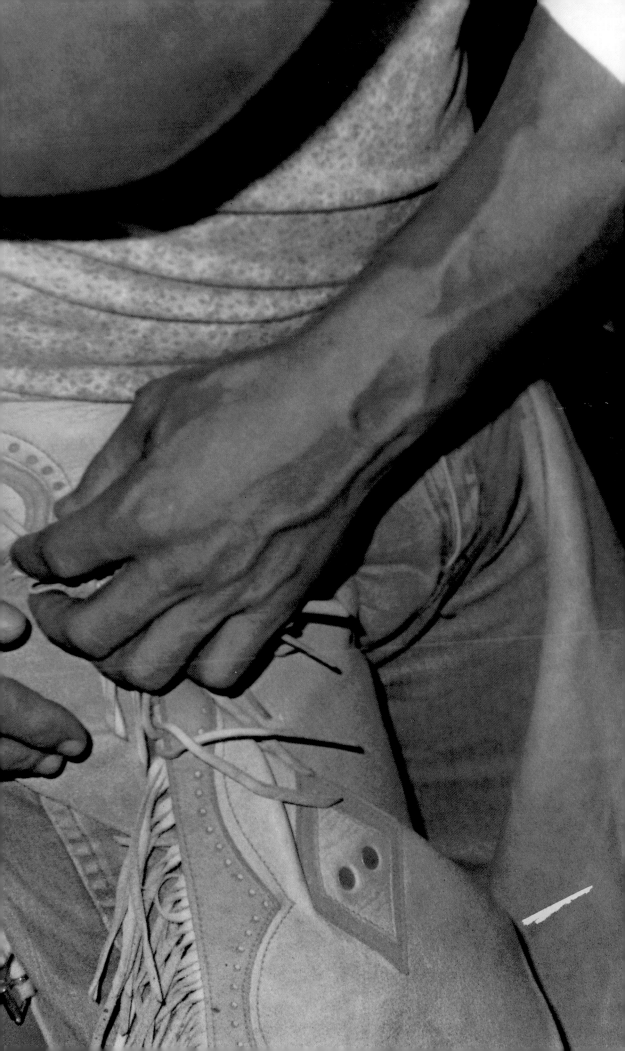

Retiring Ol' Gray

Tailor-made, we'd say
each time the chutegate cracked
and she'd buck honest—
a jump-'n'-kick rocking-chair
bronc, not a *dirty* in her,
not a single swoop
or duck: *no mallards,*
we'd laugh. That campaigner
taught us heart, those moments
she'd hang high
enough for us to dream
fancy filigree with ruby
inlays on the sun—the silver
buckle to win Cheyenne, like heaven,
Daddy of 'em All.

I'll always crave and miss
her acrobatic kick
to kiss the earth,
the way she'd break in two,
come up again for air
and float: back to back,
we'd take wing, my high
spurring stroke lifting
and lifting her from horizon
to horizon—"The Bronco Pegasus"
soaring to love
every inch of sky—rainbowing
and high rolling for the clouds
going stark-raving
wild in a crowd.

FOR RALPH BEER & JAKE WOIRHAYE

The Horseman, The Poet, The Code, The Horse

Sizing up each other's hearts, and caught
off guard by ripples of their own
reflections, the poet reveres the horseman
as high priest, the horseman beholds
the poet as wizard. In the round pen
with a gentle colt, this trinity of hearts
beats most lovingly because, with love,
nobody becomes the broken. They delight in the flying
lead change of fresh blood, fresh words,
circulating within horse, within horseman and poet,
within this circular cowboy universe
where no two boot heels or hooves—like stars,
like snowflakes or meteorites
or the blacksmith's hammer striking hot iron—
have ever fallen with the same grace,
gravity, fervor, and force
exactly to the same circle. The two men agree that,
for strangers, they agree much
too eagerly. And then, wide-eyed, again
in harmony, they nod to the synchronized wisdom
of their mentors—Hugo, Dorrance—showing them how
it's you feeling of the horse, the poem,
and the poem, the horse, feeling of you.
The horseman hands the poet an old bridle—worn
Jeremiah Watt bit and braided reins
he cowboyed with in five states. The poet
hands the horseman a thin book of works
he wrote between rodeos he rode in one-dream
three-bar towns. Seldom has either man known
an *adios* so slow. In unison they turn
toward the round corral, sudden wind
imitating the sound of wings. Angels—some say
ranahan angels, disguised as fresh western air,
will perch the circle of top rails. Hands still
clasped in their long good-bye,
horseman and poet come full-circle
to this message, to A Blessing, to friendship
lit at the withers between earth and sky.

FOR RANDY RIEMAN

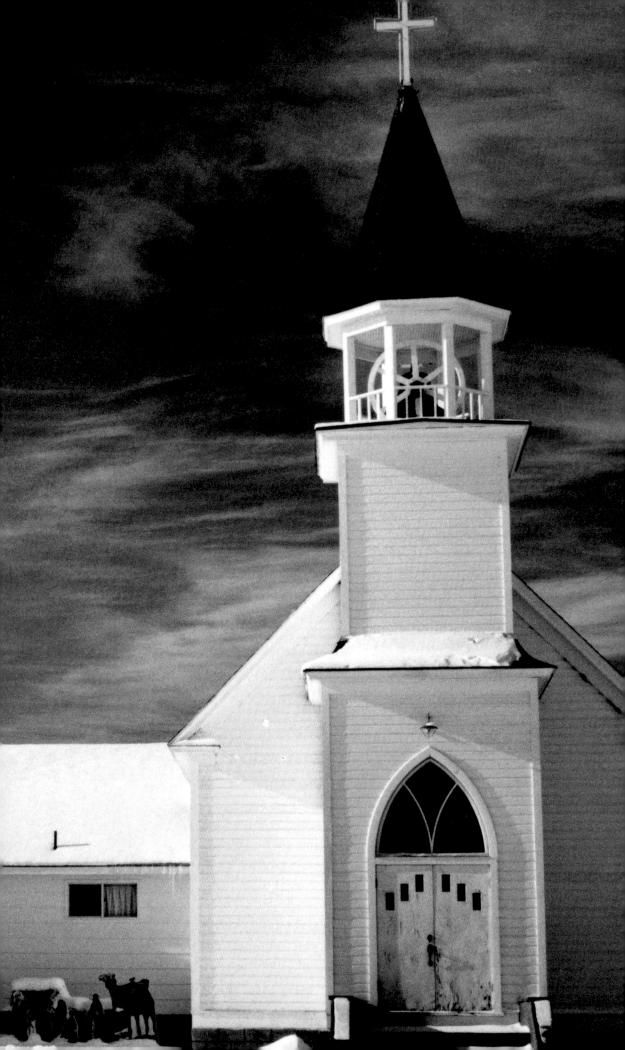

Buck

The December my horse died, I did not
go to midnight mass
to celebrate with a single sip of wine
Christ's birth. Instead, lit
between a nimbus moon and new snow,
I guzzled mezcal and mimicked the caroling
coyotes down the crick
where weeks earlier I dragged Buck
behind the pickup—horizontal
hooves at an awkward trot
in the side mirror, an image
I'll take with me to hell. No backhoe,
no D-8 Cat to dig a grave with, I left
him in deep bunchgrass, saffron
belly toward the south
like a warm porch light thrown
suddenly over those singing
No-el, No-el. . . .
 Riding the same ground
that past spring for horned cow skulls
to adorn our gates, I spotted four
bleached white as puffballs,
methodically stuffed them
into a *never-tear* trash bag,
balanced the booty
off one thigh and tried to hold
jog-trot Buck to a walk,
my forefinger hefting
the left rein to curb
his starboard glance.
 One by one,
like spook-show aliens hatching
from human brisket, white shoots popped
through that hot black plastic
gleaming in noon sun that turned
my grasp to butterfat. And when I reached,
lifting to retwist my grip,

it was sputnik flying low, it was
Satan's own crustacean unleashed, it was *the*
prehistoric, eight-horned, horse-eating bug
that caught Buck's eye
the instant his lit fuse hit powder. Lord,
how that old fat pony, living
up to his name one last time,
flashed his navel at angels,
rattled and rolled my skulls like dice,
and left me on all fours
as he did on that Christmas—high-
lonesomed, hurt, and howling
not one holy word toward the bones.

Luck of the Draw

That holy moment I rode the bay,
Whispering Hope, this rodeo arena—
like a shrine I return to, like sanctuary
or religion itself—was filled with bawling holler,
dust and hoofbeats. The blur of cowboy colors
shimmered brilliant as boyhood Septembers
among birch and sugar maples, where I played
decked-out like TV bronc twister,
Stoney Burke.
 But that was before
high school fans cheered us
galloping against rivals under gladiator lights
those fall Fridays in the pits, number 72
afire for 48 minutes of forearm shiver
and crack-back block.
 It's hard to believe
there was a time I forgot the roughstock
rider gutting it out
to the final gun, the whole
gridiron game's-worth of physical grit
concentrated, pressed into one play,
into one 8-second ride. All I needed was a horse
and the words of Horace Greeley in a dream,
a western pen pal, a cowboy
serial flashback, some sign or cue
to make me imagine the chutegate
thrown open to the snap—cleats
and spurs, chaps and pads, high kicks,
hard hits and heartbeats synchronized
a thousand miles apart.
 I left home barely
soon enough to make one good
bucking horse ride
across a vast canvas of Russell landscape
backdropped by Heart Butte under a fuchsia sky
in Cascade, Montana.
 Through these cottonwoods,

high above the Missouri River's silent swirls,
the flicking together of leaves
is the applause of small green hands, children
thrilled by a winning ride, by their wildest wish
beginning, as everything begins, with luck
of the draw, with a breeze in the heat,
with whispering hope—a first breath
blessed by myth, or birth, in the West.

FOR KIM & MARIA ZUPAN,
RED & LUKE SHUTTLEWORTH

All This Way for the Short Ride

After grand entry cavalcade of flags,
Star-Spangled Banner, stagecoach figure 8s
in a jangle of singletrees, after trick riders
sequined in tights, clowns in loud getups,
queens sashed pink or chartreuse
in silk—after the fanfare—the domed
rodeo arena goes lights-out
black: stark silent
prayer for a cowboy crushed by a ton
of crossbred Brahma.
 What went wrong—
too much heart behind a high kick,
both horns hooking earth, the bull vaulting
a half-somersault to its back—
each witness recounts with the same
gruesome note: the wife
stunned in a bleacher seat
and pregnant with their fourth. In this dark
behind the chutes, I strain to picture,
through the melee of win with loss,
details of a classic ride—body curled
fetal to the riggin', knees up,
every spur stroke in perfect sync,
chin tucked snug. In this dark,
I rub the thick neck of my bronc, his pulse
rampant in this sudden night
and lull. I know the instant
that bull's flanks tipped beyond
return, how the child inside
fought with his mother for air
and hope, his heart with hers
pumping in pandemonium—in shock,
how she maundered in the arena
to gather her husband's bullrope and hat, bells
clanking to the murmur of crowd
and siren's mewl.
 The child learned early

through pain the amnion could not protect him from,
through capillaries of the placenta, the sheer
peril of living with a passion
that shatters all at once
from infinitesimal fractures
in time. It's impossible, when dust
settling to the backs of large animals
makes a racket you can't think in,
impossible to conceive that pure fear,
whether measured in degrees of cold
or heat, can both freeze
and incinerate so much
in mere seconds. When I nod
and they throw this gate open to the same
gravity, the same 8 ticks
of the clock, number 244 and I
will blow for better or worse
from this chute—flesh and destiny up
for grabs, a bride's bouquet
pitched blind.

—IN MEMORY OF JOE LEAR

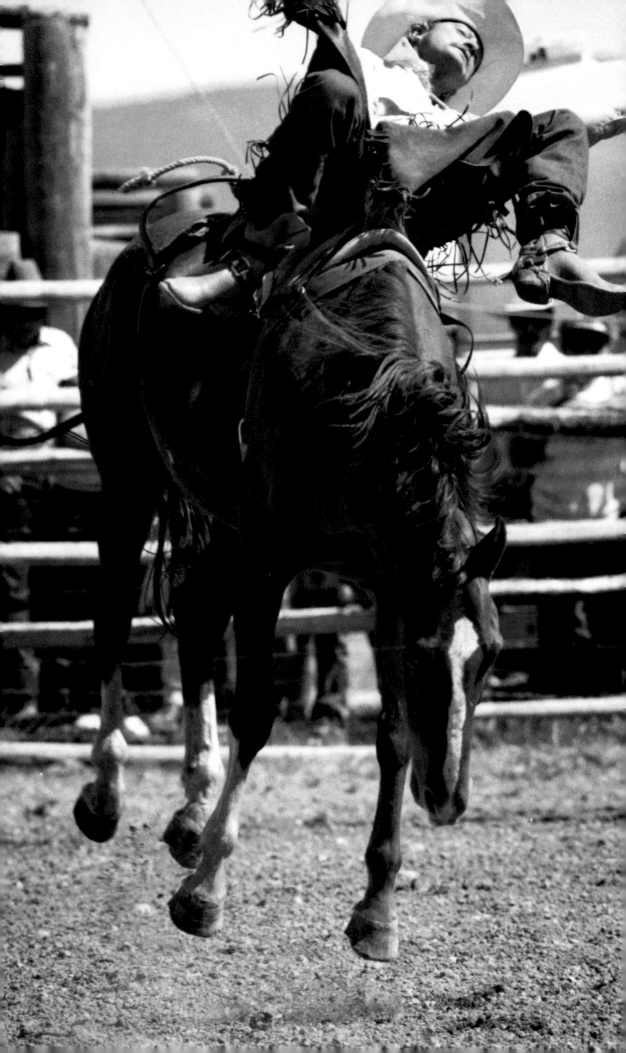

Matched Pairs

Was it the boot-cut Wranglers
you wore that night
in Butte, those copper rivets
glimmering from the hip—eyes
out of nowhere
on my lonely stretch of road? Something
magnetic caught me a moment
off guard. I forgot my only love—
rodeo—forgot good broncs and worst
pain I've had to stand, tailbone
just cracked on Willie Rock
in the first go. We danced
a cowboy waltz, holding
hands, moving smooth
as if harnessed
together since colts.

Outside Augusta, I bunk upstairs
folded in the feather bed
beneath patchwork quilts and wool blankets
sewn and woven on Grammy's ranch. Flat Creek
wind rumbles above mountain runoff
and the mothball smell lingers
in this oak room closed to heat. Sleep deep
and you'll still hear, clean through wind,
the fresh-branded calves
bawling to mother-up. Just smell
that sage mixed with manure,
leather, denim and horse
drifting from scattered boots and jeans. Feel
spirited as pioneer newlyweds
the first time together here, their faces
warmed by the same plume
of silver breath, or dream,
sparkling from this hypnotic dark.

Samurai Cowboy

Hung over from pitchers of Margaritas,
Chimayo cocktails, and crockery cruets of hot saki,
the samurai cowboy rises early and drinks
a cowcamp potful of Guatemalan roast
to Ian Tyson singing "Gallo del Cielo." He loves
this ballad of the gladiator rooster of heaven,
its heart for the battle, and how,
facing the wicked black, it sinks
a gaff into Zorro's shiny breast.
He loves how they collide and lift
into a twister of wings, beaks, claws and squawks
37 times, like rounds between bare-knucklers,
'til Gallo del Cielo's valiant death. He allows
how it's the lilt and lingo, the dance,
the passion that makes this song
his anthem. Riding or writing,
poem or rodeo, he craves the heart-pummeling,
liver-risking, soul-staking physical.

She, in black kimono, serenely irons
the denim dress she'll wear to work
in Santa Fe with snakeskin, lavender,
scallop-top Tony Lamas. She basks in
the decor of her adobe-lodgepole house,
a collage of trappings, art, and kitsch—
the Orient with cowboy West—
of braided rawhide reatas, of soft
McCarty woven from mane hair, of Hopi baskets
from banana yucca, of origami and horse clocks,
Navajo rugs, kachina and kokeshi dolls,
of bonsai and sprigs of silk cherry blossoms,
peyote buttons to fend off pesky spirits,
cholla skeleton and bamboo furniture, Zuni fetish,
and kamikaze kite. She irons with a grin,
watching him strut and fly

on adrenalined memories of old broncs
and new love, on caffeine and fiery lyrics.

He paces in the living room his pre-ride
ritual behind the chutes. He slashes
spurstrokes in his stockinged feet, left
then right, his high-stepping samurai stride,
dexterous as a cricket, toes turned out,
heels gripping against the shock-
tremor of the bronc's shoulders. He holds
his free hand high, his riding arm flexed,
fist clenched, against his trophy buckle,
to an imaginary bareback riggin', his teeth clamped,
spitfire through the slits of his eyes
as he slashes and slashes: the rodeo poet—
only a skosh mad from living too long
alone to spur the broncs—gassing it
from Missoula to Tesuque
in his antique cowboy cadillac
to cross pastoral Japanese with roughstock sonnet
with love for the geisha cowgal in blond.

FOR ELIZABETH DEAR

Escorting Grammy to the Potluck Rocky Mountain Oyster Feed at Bowman's Corner

Lean Ray Krone bellers through a fat cumulus
cloud of Rum-Soaked Wagonmaster Conestoga
Stogie smoke he blows across the room,
They travel in 2s, so better eat them even
boys, or kiss good luck good-bye for good.

Tonight the calf nuts, beer batter-dipped
by the hundreds, come heaped
and steaming on 2-by-3-foot trays
from the kitchen—deep-fat fryers
crackling like irons searing hide.

And each family, ranching Augusta
Flat Creek country, brings its own brand
of sourdough hardrolls, beans, gelatins,
slaws and sauces, custard and mincemeat
pies to partner-up to the main chuck.

At the bar, a puncher grabs a cow-
poxed handful—7 of the little buggers—
feeding them like pistachios
from palm to pinch fingers to flick-
of-the-wrist toss on target.

Grammy, a spring filly at 86, sips
a whiskey-ditch in one hand, scoops
the crispy nuggets to her platter
with the other, forks a couple
and goes on talking Hereford bulls.

And me, a real greenhorn to this cowboy
caviar—I take to them like a pup
to a hoof paring, a porky
to a lathered saddle, a packrat
to a snoosebox filled with silver rivets.

I skip the trimmings, save every cubic inch
of plate and paunch for these kernels,
tender nubbins I chew and chew 'til the last
pair, left for luck, nuzzle on the tray
like a skylined brace of round bales.

A cattleland Saturday grand time with Grammy
is chowing down on prairie pecans, then driving
the dark-as-the-inside-of-a-cow grangehall
trail home to dream heifer-fat, bull-necked
happy dreams all night long in my Sunday boots.

FOR ETHEL "GRAMMY" BEAN

The Heavyweight Champion Pie-Eatin' Cowboy of the West

I just ate 50 pies—started off with coconut
macaroon, wedged my way through bar angel
chocolate, Marlborough, black walnut and sour cream
raisin to confetti-crusted crab apple—
still got room for dessert
and they can stick their J-E-L-L-O
where the cowpie don't shine, cause Sugar Plum
I don't eat nothing made from horses' hooves!

So make it something *pie*, something light
and fancy, like huckleberry fluffy chiffon, go
extra heavy on the hucks and fluff—beaten
egg whites folded in just so. Or let's shoot
for something in plaid, red and tan lattice-
topped raspberry, honeyed crust
flakey and blistered to a luster, wild
fruit oozing with a scoop of hard vanilla!

Or maybe I'll strap on a feedbag of something
a smidgen more timid: quivering
custard with its nutmeg-freckled fill
nervous in the shell. Come to think of it now,
blue ribbon mincemeat sounds a lot
more my cut: neck of venison, beef suet,
raisins, apples, citrus peel, currants—
all laced, Grammy-fashion, in blackstrap molasses!

No. Truth is, I'm craving shoofly or spiced rhubarb
or sure hard to match peachy praline,
cinnamon winesap apple à la mode, walnut
crumb or chocolate-frosted pecan. OR,
whitecapped high above its fluted deep-dish crust,
a lemon angel meringue—not to mention
mandarin apricot, black bottom, banana cream,
burgundy berry or Bavarian nectarine ambrosia!

And how could you out-gun the Turkeyday
old reliables: sweet potato, its cousin
pumpkin, its sidekicks Dutch apple and cranberry
ice cream nut. *Ahhh*, harvest moon, that autumn
gourmet cheese supreme, or Jack Frost squash, or...
my favorite, you ask? That's a tough one.
Just surprise me with something new, Sweetie
Pie—like tangerine boomerang gooseberry!

FOR LARRY LEVINGER, CURT STEWART, JOEL BERNSTEIN,
JIMMY GAMMON, BUGS & BABE

P.S.

: Pie-Romaniac Sequel (to "The Heavyweight
Champion Pie-Eatin' Cowboy of the West")

…WHOA now just a Yosemite Sam, talkin' cockney,
Bucking Ham hop-'n'-squeal shoat of a pork
pie second! Did you say your British pie safe
is sporting savory-meat fillings? In THAT case,
perhaps I shall partake in a smashing pint-of-ale
aperitif before sinking my wolf teeth
into a Wild Bill Steak-'n'-Kidney Shakespeare Pie
to be or NOT to be cushioned in Yorkshire pudding!

OR, if thou art talking serious carnivore-bard chuck,
hold the spongy covering and bust open the pub
crust of a Cottage Pie, or Cornish Pasty Pie,
or wilder yet, a Venison-Pheasant-Hare
Pie—bloody bunny rabbit is what I hopeth
thou meaneth by that last meaty ingredienth,
however thou spelleth *LONG-EARED VARMINT!*, Lord Andrew,
in Northumberland, much too neareth Wallis-McQueary

bogs of the boiled gutbag Piper Pie, haggis—sounds too much
like badges—and *I DOE NEAT NO STEENKEEN HODGIS!* But,
aye, a cowbloke does need his *vittamins*,
not to mention his VITE-a-mins, and one or two veggies
certainly shant colic a sirloin Sir Lancelot
unless he's Randy Rieman—rhymes with PIE-man
in MY poetic cookbook—trying to choke down a Mutton-
Onion strategically disguised as Lamb-Leek Pie!

So better serve me up Piccadilly Circus, or Piscatorial
Izaak Walton Cockle, or a Rummy Swashbuckler Friar Tuck
OR, now that we've alluded to Robin Hood
of Naughtingham, why not make mine a chaste piglet
sliver of Maid Marian Marmalade Meringue,
with maybe a topless Fergie or Princess Di Pie
on the side? WHOA just a quadruple-by-pass
tally-ho-to-the-jolly-ol'-ticker artery-cloggin'

full English cholesterol-fest breakfast of a Big-
bellied-Ben minute! What would heart-smart Wallace
reincarnated from pump-dumb McRae fancy? BULLY!
ol' *schap*, but I'll *pass* on the Marbled Lard Cardiac-
Arrested Pie à la mowed-down in the wrong lane, and swerve
and swoon instead for the pulchritudinous Queen of the Cowboy
Sweet Tart Tour—Theresa Bergne Pie—Her Lady-
Godiva-on-a-piebald-Pegasus voice, her every word

making Whiskey Zarzyski—drinking Burgundy,
salivating ink—pie-eyed and burbling giddy....

FOR THE BRITISH TOUR TROUPE—
JUDY, THERESA, PETRUS, RANDY,
SUE, ROD, & ELOISE

To Wallace

I'm not applauding cathouse towns in Idaho,
nor rednecked gov'nors who reigned in Alabama.
The Wallace I tip my beaver lid to is my hero,
that Cowboy Poet Lariat—McRae—
from the Rocker Six, up Rosebud Crick, Montana.

I said *Cowboy Poet*, and those are two big words,
as tall and deep to fill as red-topped Paul Bond boots.
A Cowboy Poet cuts strong verses from the herds,
savvies cattle, horseflesh, grass, and water,
lives the history and tradition, loves their deepest roots.

And that fits Wallace, like his saddle, stem to stern—
land-loving navyman, cavvyman, pistolero poet.
And top-hand actor, too, they say, because he'll burn
and go for broke on that cowpoke hole card, heart—
Wallace packs the ace and he's damn proud to show it.

Which is why his five-gaited iambs move so true
with keen vision, image, spry rhythm, rhyme and wit.
The wise, old farrier hammering out a shoe,
Wallace loves that ballpeen-anvil chime
as he forges and he shapes each red-hot line to fit.

And how his flinty, roughstock eye can size-up folks—
between the slats, they earn his praise or wrath in verse.
From dancehall damsels to itinerant cowpokes,
his gavel's not as fast as Judge Roy Bean's,
but hanging from his gallows, made of words, is worse.

And hard—oh Lord—how he fought hard to save the land
from the greed-monger Kid Russell called *the booster*.
When they demanded coal, he showed the bastards sand—
the grit of Sitting Bull and Crazy Horse
and Gallo del Cielo, Zaragoza's dueling rooster.

Did he win? Let's just say he doesn't know defeat.
There lives within the words themselves intrinsic worth.
You bet your kack, his verse will last beyond the beat
and power of those generating plants—
a poem-ghost-rider-posse crusading for the earth.

Here's to Wallace. Hoist his tartan like a bardic flag.
Long may the lingo of his calling ride the Tongue.
Montana's Robert Burns hard-charging with a brag
like ol' Casey on a bronc, Wallace,
reppin' for the legendary, keeps the old West young.

FOR RUTH, CLINT, ALLISON & NATALIE

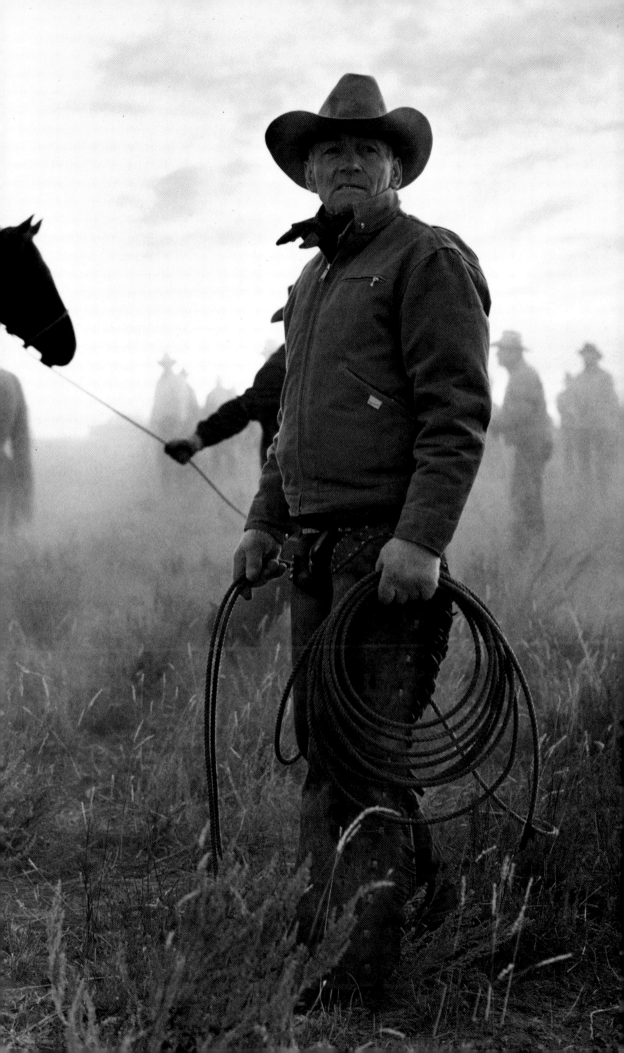

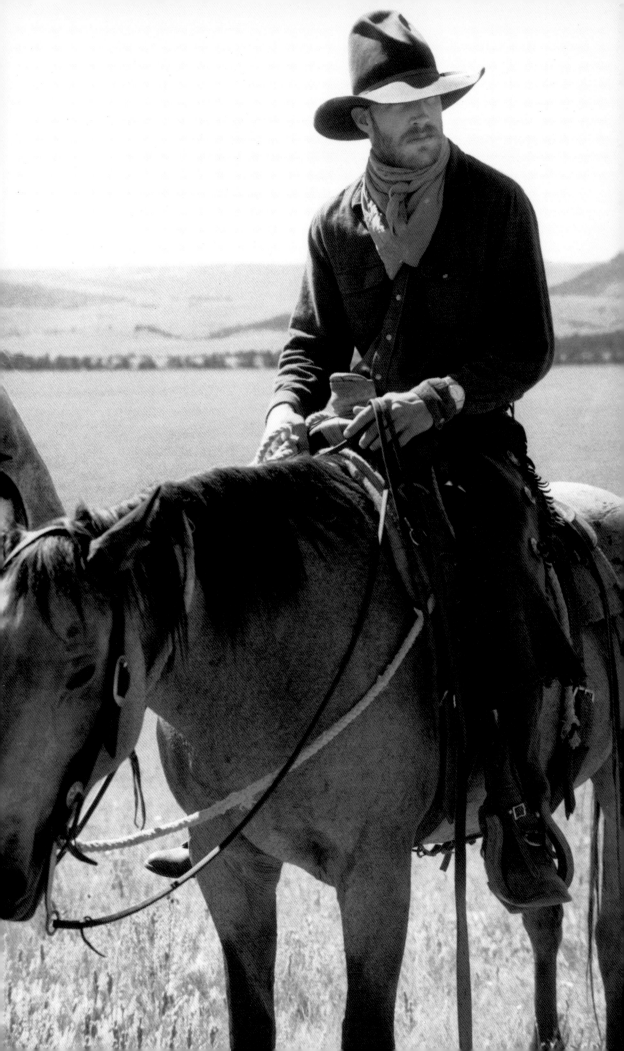

Talkin' Roughstock

Sonny Linger taught son Patrick to talk Roughstock—
the sinewy-sweet words to a bucker's perked ear.
They'll make a bug-eyed bull or bronc
kicking lathered at the slats
quit his boogering and listen—
hooley-anns of jingler lingo looped on every fear.

Roughstock's not a tongue that's taught to any gunsel.
You must be born with mustang running in your veins.
No fancy cues in hackamore or snaffle,
but pure-quill family savvy
graces you with equine eloquence,
bovine jive, and that knack for shaking rank ones' manes.

Strutting proud as high-falutin Andalusians—
Strawberry, High Prairie, Reller's Wreck, Pack Train, Feek.
They paraded, like it was their own choosing,
down those alleyways, legged-up
strong from pawing winter feed—
pumped on grain plus pep talk, all heart and muscled sleek.

Rockabar, Davy Crockett, Snake, Blue Blazes,
were not just livestock to the Lingers—they were kin.
Buffalo, Whispering Hope, Mr. Davis,
outgunned, by *just a skosh*,
my big-screen boyhood heroes—
Rowdy, Roy, Stoney Burke, The Duke, and Paladin.

Pat and Sonny sure-enough talk Roughstock.
They'd speak, as well as breed, the buck into their band.
They'd coach their broncs to rock-'n'-roll
and teach us sand for the fandango
in a language likely crossing
Spanish with Comanche with Roman, Greek, Cheyenne.

Each 8 Linger seconds was a separate life,
a beautifully pure and smooth and simple facet.
We'd crack-'er-back, slide-'n'-ride
with Sonny pulling flank straps
and Patrick, braced against the gatelatch,
coaxing stock and cowboy *Gas-it! Gas-it! Gassit!*

Sonny and Pat, Pat and Sonny—how they, by God,
 Talk Roughstock.

FOR BESS, AMBER, LORI & TOM—ROUGHSTOCK TALKERS ALL

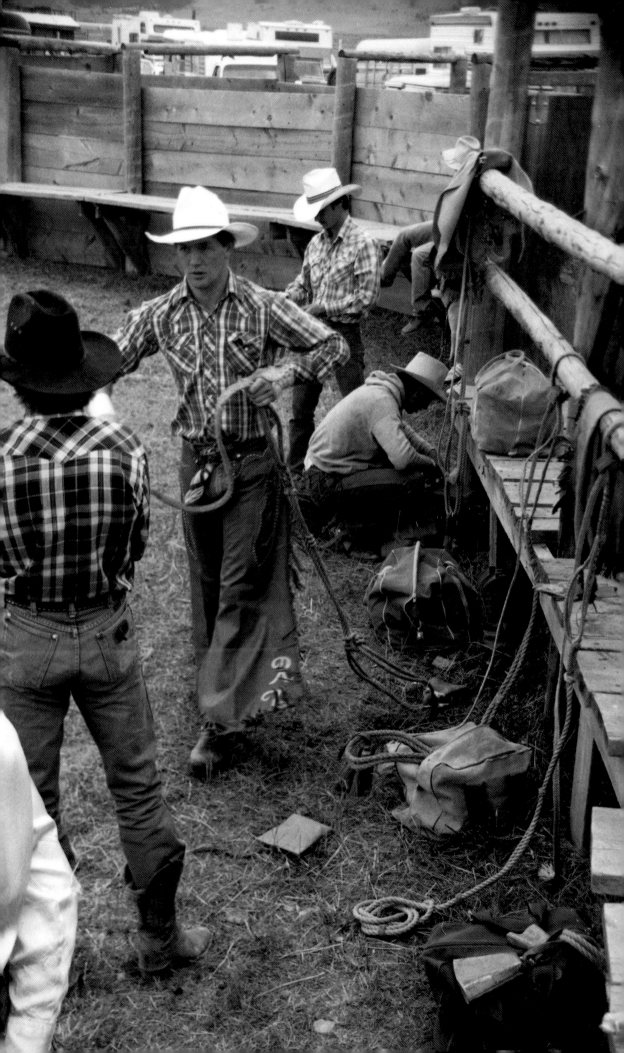

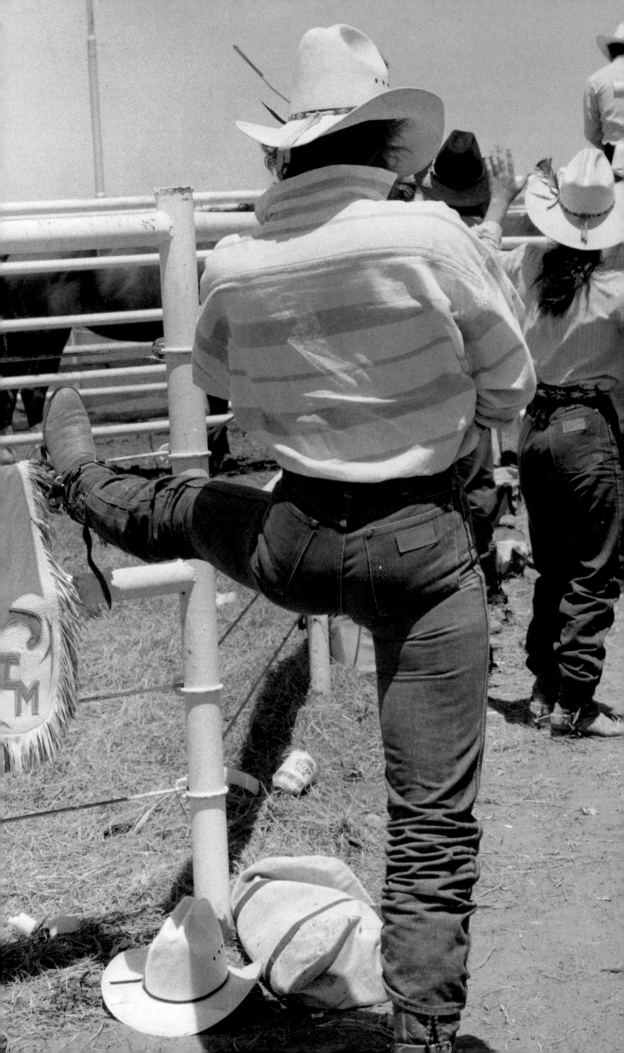

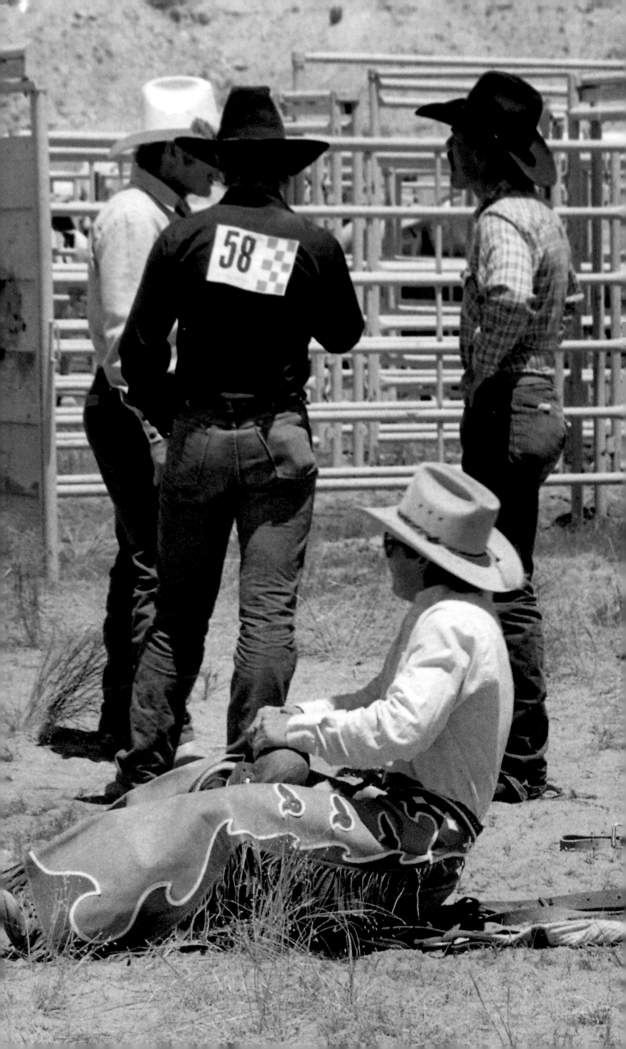

Song Moment for Ian Tyson

Gripping the latigo-leather straps of the black canvas
riggin' sack in his riding hand, he reaches through
the wood-beam trestle's latticework into the darkness
out over the river. It has never felt this heavy—never
felt this light. As if blackness has embraced blackness
and it has become buoyant in the black air. As if his
flexed forearm and elbow, wedged in a vee of trusses,
have petrified and grafted there.

He has finally decided to leave the arena of men behind,
to let go of his first lover, rodeo, and now he feels
suddenly lonely and anxious in a world of women.
The river-purl below is a woman's whisper beckoning;
the evergreens in the wind are dancehall girls in frilly
skirts and fishnet stockings; the land surrounding him
has ten thousand breasts; the night sky is a picture-
show aglitter with women's firefly eyes. And she is
locked hip to hip against him, his free arm wrapped
behind her and reaching almost all the way around—his
hand spread wide, his thumb pressed to her breastbone,
his fingers against her ribs like a blues pianoman
holding a sad last note he wishes he could hold forever,
or at least long enough to drown out the sound of a
splash. He has always feared deep water.

With one arm draped around his shoulders, she reaches
her free hand out and cups it over his fist clenching
the riggin' sack's straps. As if waiting for the opening
note to the next waltz or tango, they hold that pose
for what seems an eternity. So far they have not spoken
a word. They touch and feel their way through the intricate
steps, because they know it is the dance, not the dancers,
that matters most. As his strained arm begins to tremble,
she trembles with him. And who's to say the trestle does not
also tremble, as it did thousands of nights long ago

under the steam locomotive's lumbering, rocking gait—
bison bulls with their harems in tow. Who's to say this
couple must not hold fast until their rodeo ghosts can hop
the ghost freight passing beside them now?

Because she has been down the road herself, because she
has won and lost, and has seen him win and seen him lose,
and now, maybe, will see him walk away from roughstock
for good, she is the only woman who can know. Not only
that, but she has let other men on other bridges on other
dark nights hold on to her while they tried so hard to
let go of other boyhood dreams. She cannot help but wonder:
does the river—like a train, like a life—have its own
mysterious roundhouse way of circling back?

He breathes deeply into windy swirls of her auburn hair.
Beyond her shampoo and perfume, beyond the faint whiff
of water- and wind-worn creosote, he smells the sweet
rosin breeze through limbs of ponderosa and western fir.
She feels his fingers tighten around the straps and to her
ribs. And he feels the tempo of her heart, a snappy bronc.
Hang-on. Hang On! she had cheered so often to herself
as she'd watched him ride—the Barstow bareback riggin',
Hank Abbie horsehide glove, and Blackwood spurs, helping
him keep those hammerheads gathered beneath him for 8
seconds, now all out over the river. It is not easy for her
even to wish *let go*. No way could she ever whisper it.

So maybe it was the full moon rising for the first time
in decades without its blue roan bucking horse shadow. Or,
maybe the wind through the trestle's framework making
the joyful sounds of the Zuni flute player. Whatever it was
that turned them loose, it was as if they'd been swept
upward like helium figurines dancing across the night
sky—the stars marking the spots where they touched down,
ever-so-lightly, with the toes of their boots.

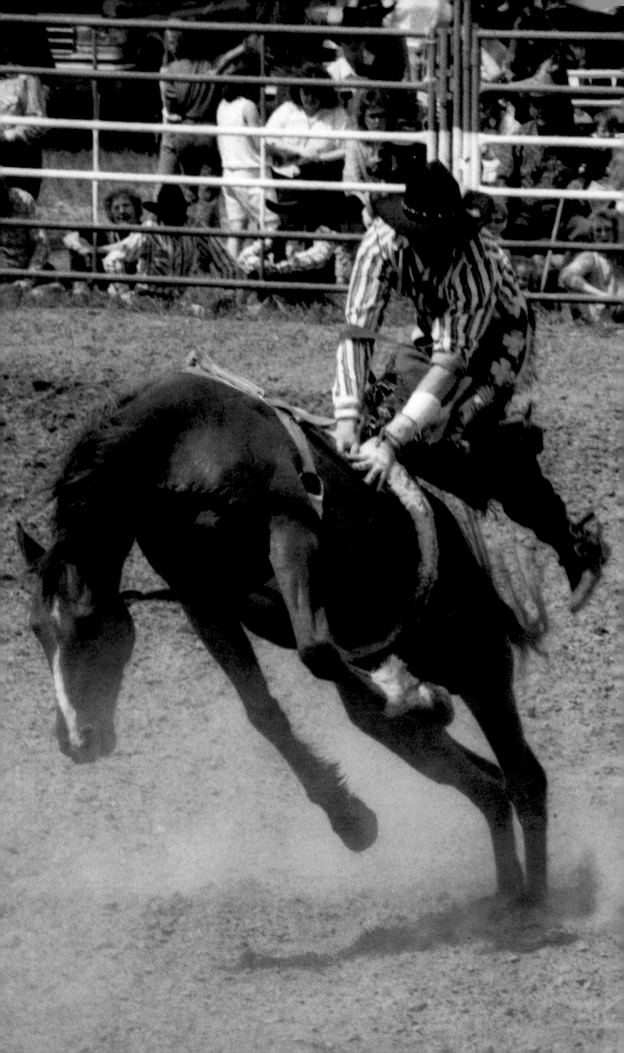

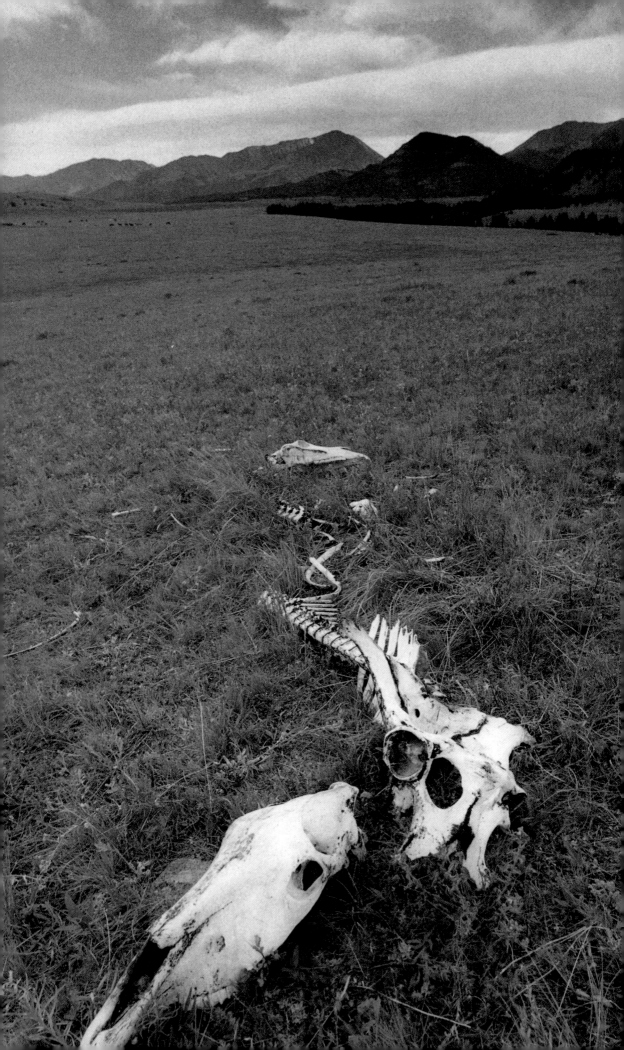

Monte Carlo Express—Box 258, 15.3 Miles Home

I've checked fence doing 80 in a low-rider
Chevrolet springing the borrow pit
like a pack mule that hates crossing
running water. The torture is too much
when a week's-worth of mail—stacked
beside me like a high school majorette
beckoning with her baton
decades back when this car was showroom new—
presses against me. I could never wait and still
can't wait to open what's personal. Steering
with my knees, jackknife gleaming in my lap,
the wheel tilted down full—The Monte, a roulette
ball blur hugging hot asphalt—I shuffle
through the stack and gamble
once again on 8 miles of 2-lane
straight-away. I frizzbee bills and all business
glassine-windowed envelopes,
in which we poets never receive checks,
over the suicide seat headrest, toss
junk mail to the floor-mat collage
on the shotgun side, stick love letters
between my teeth, and maybe I'm better off
not having tasted perfume
for years. *Esquire*, slicker than a hot plastic
sack of slimy grunion, slithers and slides
over, under, and between the seats
leaving its Stetson Cologne scent
like a madam's tomcat mascot marking his turf
on two-for-one night
in a cowboy brothel. Ol' Monte drifts
left across the double yellows on a hill
then right, into the shoulder brome, seed heads
whipping the wheel wells clean, dust swirling
in the side mirror, the Day-Glo
rubber fish in place of Jesus
dashing for the stuntmen grasshoppers
suctioned to the windshield,

their front paws clasped in prayers
that must have saved us from the bridge
abutment already signed
with 4 white crosses for those who did not
quite

 make

 this

 curve
because of booze, because of snooze, because of
tire or tie-rod act-of-God failure
of car or heart, or the piss-poor
penmanship of a good friend
loving me almost to cursive death with this letter.

FOR RED SHUTTLEWORTH

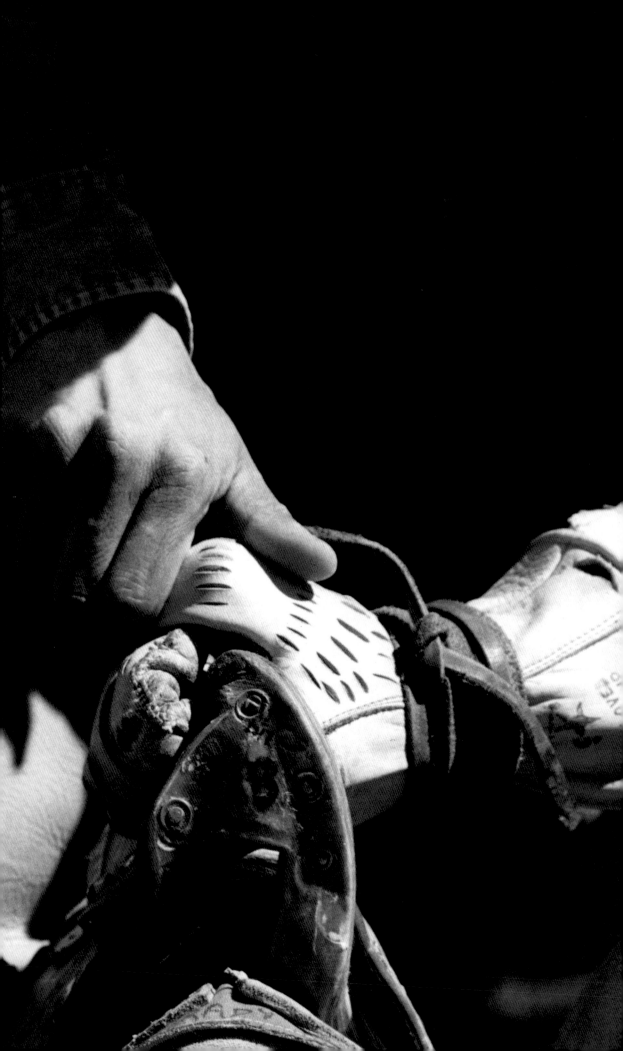

After the Blue Norther, Another True Story

Frozen glint off moonlit bumper chrome
coasting slowly through the final turn
toward the windswept graveyard's iron gate
was the first solid glimpse of him
the rancher, calvin' heifers, finally caught
though he couldn't say how early or how late

that eerie day, but he kind-of saw a cowboy-
hatted silhouette, weaving 'mongst the stones
always lit a skosh there in the moonlight,
and when the figure stopped, the hat was gone
as the shadow seemed to bow, then melt
into the ground, and disappear from sight

but not from sound, cuz the rancher knows
there's no such thing they call *dead calm*,
knows to open up his mouth and cock an ear
into the coldest silver silence
when minus-50 air is crystalline—
the sweetest chime, the highest steeple bells you'll hear,

but *this* was rhyme, he's sure he heard,
in jog-trot meter, bits and spurs a-jingling
while one marker's epitaph lit up like brands—
you know, on angus calves? that rawhide white
that seems to radiate?—the rancher
cupping both ears, closer, with cracked and swollen hands,

while through his tears—he'll swear the cold,
damnit, made him weep that morning—
he listened to the stranger say a poem
that chilled the brood mares in their tracks
not a single crunching hoof, nor breath,
a billion eyes, unblinking, from the dome,

but it was cries of coyote choirs,
to the poet's lines that raised the flesh
toward heaven like no preacher ever could,

that poised the rancher, pious, in his tracks
there in the presence of the purest love
only true friends know, and then the cowboy poet stood

and drifted, slow, back toward his rig.
The icy squawk of hinges on the graveyard gate
finger-snapped the rancher from his trance,
but 'fore his wits were fully gathered
the tail lights of an older four-wheel drive
dropped behind a knoll, not giving him the chance

to pinch some Skoal, calm his nerves, and warm
the Ford up fast enough to chase the stranger down
to praise him for a legacy fulfilled,
but he drove up to the cemetery
anyway, where echoes off the snowdrifts wrapped him
ghostly as a shroud, yet did not leave him chilled

but warm and proud. And now, mostly, it's *his* story:
how cowboy poet friends, closer than the bond
between the metered beat of hooves and solid ground,
defied that custom swather, Father Time,
to cut them off from love they shared
for words, still ringing, wintry nights, above the mound.

Rodeo-Road Founder: Highway Horseplay

Say horses were elk, and elk
horses: eyes around every elkshoe
curve would pack more weight, spook me
worse, and I'd be glued to the wheel, pulling
leather all night long, from Alberta to Cranbrook,
B.C., Sandpoint, Couer d'Alene . . . after 8
hang-and-rattle seconds—spur to antler—
locking horns with a bucking wapiti.

Say elk were horses, and horses
elk: it's a long, hard haul after all but 1
of your 9 lives flash before your eyes
aboard a bugling cayuse, especially
when you draw ol' Velvet Double 7,
triple rank, his royal head of ivory
tines stabbing, battering you
half to death and sensless.

Say horses were elk, and elk
horses: caution
sign language would change in silhouette
and mustang eyes would shift
at different gaits from borrow pits
to the center of your lane. Daybreak,
you'd see compact cars, not ungulates,
chassis-up and driving magpies mad.

Say elk were horses, and horses
elk: you'll say anything, won't you,
you knee-jerkin', suicide-circuit-
chasin' maniac of a loon—any singsong
screwball thing to stay alive when you're dead
tired, gassin' and mashin' it,
gettin' your holts and yodelin' down the road
rodeo to rodeo to rodeodeodeo . . .

FOR INSANE-WAYNE, TNT, LLOYD,
TERRY, STEVE, LITTLE JOE & SHADD PIEHL

Staircase

How can lovers of buckers lament
a favorite bronc down
and dying on timberline range
we glass for elk—meadow
he's pawed to a raw circle
around him like mool. What can we say
under this scant angle of Montana
half-moon, when we wish the whole
universe would grieve
for one rodeo star, throwing all
his heart into each roll
and futile lunge for all fours—
first stand he learned
as a colt, gravity back then pulling less
against him.
 Like two helpless sailors
marooned with age, and mourning
a familiar orca beached
in the storm's debris, we crutch
our feeble human frames
beneath the horse's weight and heave
each time he tries. The Rockies return
our holler in a salvo of shouts,
grandstand uproar
we hope will spring him
to his feet. We pack-in water, last-meal
grain and pellets. No way can we swallow easy
looking into the white of a single eye
sinking, giving in to red. No way
hunters can repent—can we take back the metal,
aimed or stray, sent through flesh.
 Riflefire
across this big-game state
echoes reports of 44 wars
from guerrilla worlds, the unarmed falling
fair prey as varmint, as target,
when killing comes
nonchalant. What's one shot more—mercy
or otherwise—one more animal soul

to this planetful of procreating shots
and souls.
 Yearlings gallop a kettledrum
roll along the rim. What I can say
in light of this violent world, I hold
silent: Staircase, number 12,
bucker who broke my partner's neck in '78,
who flung me off 3 times
to hometown fans, I wanted this
life of ours—love for what hurt us most—
to last a full, eternal, 8 seconds more.

FOR JOE PODGURSKI

Partner

As you hit ground off Staircase,
number 12, at the state fair
rodeo in Great Falls, it was hard
to hear vertebrae cracking
above the murmur of ten thousand
hometown hearts. You cowboyed-up
and hid your grimace deep,
walked out of the arena,
stubborn, on sheer pain
and took the ambulance, like a cab,
front seat to Emergency.

Tonight, drunk on Tanqueray,
we vow never again
to mention broken neck. Instead
we talk tough broncs, big shows
we'll hit down south, and hunting ducks
come fall. We straggle home,
moon-struck, to the squawk of geese—
a V of snows crisscrossing
and circling the city—screwed-up,
you say, when streetlight glimmer
throws them off plumb.

When my bronc stomped
down the alleyway that night,
I knew down deep our bones and hearts
were made to break
a lot easier than we'd believe. I felt
your arm go numb in mine,
took the gate, weak-kneed, and spurred
with only half the try. It's bad
and good some cowboys don't know tears
from sweat. I folded both
between fringes of your chaps,
packed your riggin' sack neat
as you'd have, and wandered

punch-drunk lost, afraid
into the maze of parking lot.

What's done is done, I know,
but once I killed
at least a dozen singles
in a season, without thinking
how they partner-up for life
and death, how the odd ones
flocking south
survive that first long go alone.

FOR KIM ZUPAN

The Night the Devil Danced on Me

A werewolf moon glares
from the top row of bleachers, horned
owl with one eye plucked. In the black hole
of chute 8, Lonewolf waits—
an ugly bronc, mustang and rank,
the cowboys say, with notched right ear
and snaky, suck-back ways.

When a sluggish Montana sun goes down,
the crowd packs home its cheers, the screak
of warm rosin and rawhide
echoes in the arena, and nostrils
bellow the horse's hot snort. I crack-back
my hand in the riggin', the binds locking
with a squawk, the bronc coiling below me.

Above the chute, a jury of broken cowboys
against dusk, silhouettes of crooked limbs
in an old orchard, and heartwood faces
that stare, like kids look into the gullet
of a homestead well. I call for the gate,
hinges shriek, sand hisses against the chutes
with every kick—moons dive in a dirty sky.

Lonewolf hurls me down
to his farrago of shadows. I'm hung, prey
under the belly, swung in a fury
of hooves and spurs—claws in the dark:
ground is a black thunder cloud
and my chaps swoop around me
like huge wings of a hungry bird.

The Night I Hated Baxter Black...

...I'm convalescing in a double-sawbuck
 motel suite in Havre.
I'm splurgin' for remote TV
I'm slabbed-out in my BVDs
All I need's a john doe toe tag
And I'd pass for a cadaver.

Cuz I'm the victim of a suck-back
 bronco's belly button pirouette.
My innards burn each time I breathes
Like a pot of red menudo seethes
I clicks to channel double-ought
Hey! There's our poet-hero-vet—(which rhymes with pirouette)
 It's Baxter!

And I'm Buted-up with a sack of Igloo
 Ice Cubes on my tummy.
It's either Bax or Butthead-Bevis
Wow, some choice the TV leaves us
It just hurts too much to laugh
And, well, Bax ain't half as funny.

Until, that is, my puppeteering toe,
 sporting Baxter's hat, begins to wiggle.
Way down at the foot of the bed
My hairy bunion wears HIS head
That ol' Quasi Mo-TOE poet
Made all those ice cubes jiggle

Against both my dislocated thumbs
 poked through that cube sack from above.
Too much cacklin', I can't take 'er
I feel just like a paint-can shaker
I'm convulsing on the crumbling edge
And THAT'S when Baxter gives a shove.
 AND I quote:

I like a truck that looks like a truck
 and not like a tropical fish.
Twas his poem 'bout cowboy pickups
Put the hotshot to my HICcups
My whitecapped bladder's burstin' — say,
Like plums in your pocket'll squish.

OOH, that night I HATED Baxter Black
 for the way he kept me squirmin'.
With each laugh, the painful fire
My intestines full of wire
What I really need's a magnet
And an Ivermectin wormin'.

But NOOOOO, he's turned his vet'inary
 clientel to rhyme-'n'-meter fans.
This cowpoke-lingo gym-NAST
This Rush Limbaugh, after Slim-Fast
If Elko's all a fairy tale
He's mustachioed Peter Pan

Dressed in Betsy Ross's leotard! With Tinker
 dusting him in sprinkled ink!
While Baxter's raking in the dough
I'm giving him the Van Gogh toe!
I'm laughing in the face of pain!
I'm hoping I don't tinkle pink!

And then that Silver-bellied cuticle
 threw the one-two coup de grace.
IT did the mountain oyster poem
I slipped a jagged kidney stone
Just something 'bout the way IT said
SHE said, I'll have mine rawww.

The remote control has disappeared into foam-
 rubber folds of bedding.
I'm a casualty of humor
When I hear that line from "Junior"
. . . a backhoe bucket for a codpiece?!
Twas that plastic I heard shredding?

My sack of ice has turned into a
 pachydermic prophylactic.
Ol' Black has milked his 6th encore
My sagging toe is cramped, what's more
MISS PIGGY couldn't hold her own
When Baxter's spastics go galactic!

OOH, that night I hated Baxter Black
I learned how laughter is, in fact,
the bronco-twister's PURE elixer.
The next day I spurred to win
'Tween hate and love the line's so thin
SO, if your cowboy try should ever crack
Go see that cow-doc poet, Baxter Black,
He'll patch you up with laughs and,
I'll bet my friggin' riggin' sack,
Those laughs will SUREly fix 'er.

A Cowboy Reel

Ain't a hand been hatched since 1950,
You'll hear some *real* cowboy pontificate and pine,
Just a bunch of wanna-bes,
Hopalong-come-latelies,
Compared to him, who's born, of course, in 1949.

The real cowboy's rare as hen's teeth,
As watermelons vine-ripened in Alaska—
Extinct as Brontosaurus,
On the plains or in the forest,
But these purebloods, they'll just brashly up and ask ya,

Ever seen a gen-u-wine, authentic, real cowboy?
Who rides a real rank real mustang to head and heel?
A true waddie, a ranahan,
A leather-poundin' cavvyman?
Well, maybe not, but I *have* seen a cowboy reel

From the deck of a pitchin' green-broke colt,
While spin-fishin' in the middle of Flat Crick.
It was back in '83,
Who cares what century
When you watch a boiled-over pony jump and kick,

Because my partner set all his hooks
Into a missile of a fish *and* his horse, who followed suit
With acrobatical gyration,
No room for arbitration—
This scene reincarnated 'neath Charlie Russell's butte,

Where my partner lives, and lives to eat
And hunt and fish and ride with all his heart.
I could hear his belly growlin'
Through the rockin' and the rowelin'—
He was set on havin' charcoaled cutthroat à la carte.

Now it's true that Flat Crick ain't the Mighty Mo,
But she's roily and she's knee-deep on a leggy hoss
Who's fightin' for a holt

With every bolt and jolt
Over boulders, loose and round and slick with slimy moss.

But my partner keeps on reelin' with both hands
And ridin' Rooster Cogburn–style in a fight—
The reins are in his teeth,
Moby Dick is underneath,
But he's holdin' rod-tip high and his drag is set just right.

By now, the colt's a whirlybirdin' blur,
With monofilament racin' underneath his tail—
A helicopter Pegasus,
More Big Spins than six Las Vegases,
We later named this dance The Bronco Bail,

Which, on a fishin' reel, is the part that guides the line,
And my partner's bail is smokin' somethin' mean—
Sons-a-bitchin' friction
(Please excuse my diction)
From drag to croup the shittin' line's a streak of neon green.

So this is what it means to *horse* a fish,
'Stead of playin' him slow and easy to the bank.
When four hooves hit terra firma
Like the hurricane named Irma
That fish slapped smack against that horse's flank,

Which sent the trio trollin' through thin air,
In Montana, where daredevils make their home.
In the eye of this upheaval,
More Evil than Knieval,
I know I saw a sure-enough *reel* cowboy roam.

Does my bad spellin' discombobulate the question?
To reel, or *not* to reel? still rings a bell.
To all you bellyachers,
Be you reel or be you fakers,
'Til you've fished while pitchin', there just ain't no way to tell.

FOR CURT STEWART

She Holds Her Favorite Cowboy Close

Wristwatch strapped over his cuff, a hand
thick as a tractor manifold
pivots off his daughter's shoulder, his arm
looped around her with savvy
he's used to slip bridles
on 45 years of colts—*easy now*—
as not to spook a single curl
tumbling beneath the powder-blue Resistol—
easy now—as not to foul with diesel or grease,
or the smell of hooves he's just shod,
her cotton boot-length dress, her satin sash
embossed in silver. She's the crowned
queen and sweetheart of the Fremont County Fair
& Rodeo. No mimicked cowboy myth
poses against *their* yard fence—
the burrowings of bark beetles in slab
pickets like swivel-cut leather—
against spirited horses grazing
blurred acres beyond the camera's depth of field.
No fat or phony frills taint *this* span
of father-daughter, lean grin and wide smile
matching perfectly the casts
of their trophy buckles beaming side by side,
and the speckle-faced Aussie cowdog, squatting
perk-eared and cocked for some action he craves
outside this frame. The West before wire
still rides the lineage of this family ranch
where broncs, pastured with the bridlewise,
fashion a soft backdrop for lovers
of horses—like father, like daughter—
blue-ribboned in their Wind River embrace.

FOR CATHY GRIFFIN JACOBSON & THE MANTLE FAMILY

The Bucking Horse Moon

A kiss for luck, then we'd let 'er buck—
I'd spur electric on adrenaline and lust.
She'd figure-8 those barrels
on her Crimson Missile sorrel—
we'd make the night air swirl with hair and dust.

At some sagebrushed wayside, 3 A.M.,
we'd water, grain, and ground-tie Missile.
Zip our sleeping bags together,
make love in any weather,
amid the cactus, rattlers, and thistle.

Seems the moon was always full for us—
its high-diving shadow kicking hard.
We'd play kid games on the big night sky,
she'd say *that bronco's Blue-Tail Fly,*
and ain't that ol' J. T. spurrin' off its stars?

We knew sweet youth's no easy keeper.
It's spent like winnings, all too soon.
So we'd revel every minute
in the music of our Buick
running smooth, two rodeoin' lovers
cruising to another—
beneath Montana's blue roan
bucking horse moon.

The Augusta perf at 2, we'd place again,
then sneak off to our secret Dearborn River spot.
We'd take some chips and beer and cheese,
skinny-dip, dry off in the breeze,
build a fire, fry the trout we caught.

Down moonlit gravel back to blacktop,
she'd laugh and kill those beams for fun.
That old wagon road was ours to own—

30 shows since I'd been thrown
and 87 barrels since she'd tipped one.

We knew that youth won't keep for rainy days.
It burns and turns to ash too soon.
So we'd revel every minute
in the music of our Buick
running smooth, two rodeoin' lovers
cruising to another—
beneath Montana's blue roan
bucking horse moon.

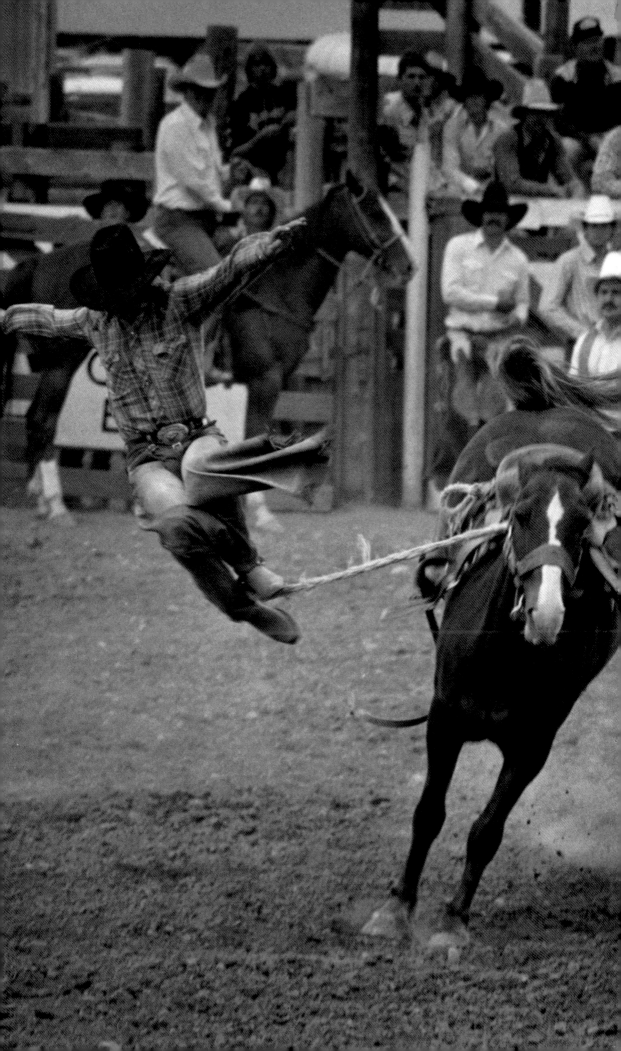

Pegasus, She Ain't

Easy-keeper, grass-bellied and grained
for life, old Cody follows her foundering nose
through the yard gate I leave ajar
thinking without horse sense once more
there's nothing save the house
she can mistake for a feedsack here!
Just a fast splash of java
and maybe a graham cracker is all
I hankered for, just a fiver
without distraction before going back
hard at it. So when I glanced
up from the kitchen table in the middle
of my first cracker's dunking, to see her tongue
lashing the bird feeder hung from a branch,
left then right, like a heavyweight
working the speedbag to a blur, *WINGS*
give the birdbrain WINGS! is what
I snorted leaping for the door—
give her frigging wings and she'd perch
the sapling like a catapult
to the ground, fight the chickadees off
for the last millet seed, crib
every limb, girdle the trunk,
strip the leaves, then flitter
off in search of real meat! I was two-cock mad
reaching up to unhook the feeder,
but patient sort with horses that I am,
I tell you damn straight I did not see red—
not back when she raked her canines
across the fresh metal-flaked
candy apple paint job on my classic Monte Carlo
on her way to snap the antenna off the Ford
did I see red. Not one nanoiota of red
then, nor the umpteen times she snipped
and scattered like the Wizard of Oz scarecrow
the moldy black straw bales holding my roping horns—

though I will admit I did see pinkish-
purple when she harvested in July, turnip greens
to swiss chard, sweet corn to cucumber shoots,
the entire garden, leaving behind
neatly in one corner her steaming heaps
of next year's fertilizer. But not even then
did I see red. I did not see red—
florid, bloodshot, fevered, carbuncular-festered-gore
red—until her sorghum-seeded tongue rasped
the soggy graham cracker off my wrist.

pril Showers

Most broncs I've rode were satisfied to spite you with a fart,
an echo to every pair of holes they'd punch through air.
But one crude pony throwed its kidneys, as well as heart,
into eight juicy monsoon seconds, epitomizing
how a stud or gelding aims more civil than a mare.

She was owned by howling broncman old Bob Schall,
whose faintest whisper ball-peen hammered mirrors.
No doubt, he salted down her feed, kept her in a private stall,
doctored-up her water with a jug of diuretics,
cuz she'd let blow like someone holding back a hundred beers.

I swore she'd waterlog herself from show to show—
compared to April, Yellowstone's Old Faithful was a squirt.
With every jump she'd let that hydrant gusher go,
she'd drench her tail, pistol-whip you blind,
leave you looking jaundiced, make you burn your shirt.

The rulebook adamantly states you got to wear a hat,
and me, I'm partial, even in the heat, to beaver felt.
My Resistol resisted scours, gumbo, blood, and buzzard scat—
even soaked and shaped it once with rotgut rye—
but April's frothy acid sopping made the damn thing melt.

Funniest, though, was when some rookie'd pluck her from the draw—
as he'd size her up between catchpen rails, she'd nicker.
She ain't rank, is she? he'd beg us all to tell him *nawww*,
but finally, what burst our briskets was his face
bewildered by the flankman wearing waders and a slicker.

But you'd never turn Miss April out—she was tailor-made,
a skosh easier to track than, say, Sonny Linger's roan.
Sacrifice a little pride and hygiene and you'd get paid
and learn what virtues lie in celibacy,
plus solitude, as you'd go home or down the road alone.

April Showers brought you no May flowers—nor a pick-up man!
She'd send you retching, reeking, sloshing to the nearest trough.
Win or lose, a swarm of flies was still your only fan,
and though she'd seldom spill a twister pitching
that sluicetail cayuse sure did *piss* some good ones off.

FOR DON & DOUG CLARK, TUDO STAGNOLI, LUCKY FROST,
WILD BILL STOCKTON & BOB SCHALL JR.

The Roughstockoholic's "Just-One-More-Last-One" Blues

What I would pledge for one more horse?
I'd drive a Rambler, scrap the Porsche,
I'd swear off beef and live on borscht,
And I'd improve my rhymes, of course—
I'd dee-vorce free-verse for that horse.

What I'd do for just one bucker?
Throw back the trout, keep the suckers,
Turn down a date with Tanya Tucker,
Sell the cows, start ranchin' cluckers—
I'd hang-glide Baghdad for that bucker.

What I would don for one last nod?
I'd don a tutu, wear a cod,
Wear kilts and moon you while I shod,
Across this stage in jodhpurs, trod—
I'd don white Acmes for that nod.

What I'd try for one last fannin'?
I'd try my Nikes, never ran in,
I'd try Jap cars, try sushied salmon,
I'd try a *real* hat on Hal Cannon—
I'd try wine coolers for that fannin'.

What I would quit to spur one more?
I'd quit the pies I eat galore,
I'd mums the word, my galfriend snores,
Quit shootin' polecats through the floor—
I *might* quit pies to spur one more.

What I would swap for just one bronc?
My Buckhorn Beer for Chenin Blanc,
Ol' Dunny's nicker for a honk,
Swap gun for club, just call me *Gronnkk*—
I'd walk on knuckles for that bronc.

What I'd do, once more to gas-it?
I'd breed my heeler to a basset,
A FREE BEER sign? I'd shrug and pass it,
Tell Mastercard to kiss my asset—
I'd liquidate, once more to gas-it.

What I would risk for one more lick?
I'd hand-feed pumas tofu sticks,
I'd call the sumo champ a *Plick*,
My galfriend's barrel horse, I'd quick—
I'd risk PURE fury for that lick.

One nod, one bronc, one lick come true,
One more last ride, I *swear* I'm through!
I'll wrangle dudes—*toodle-oo!*
I'll move down under—buck a *roo!*
Did I say *one?* Let's make that two.

FOR KIM ANDERSON

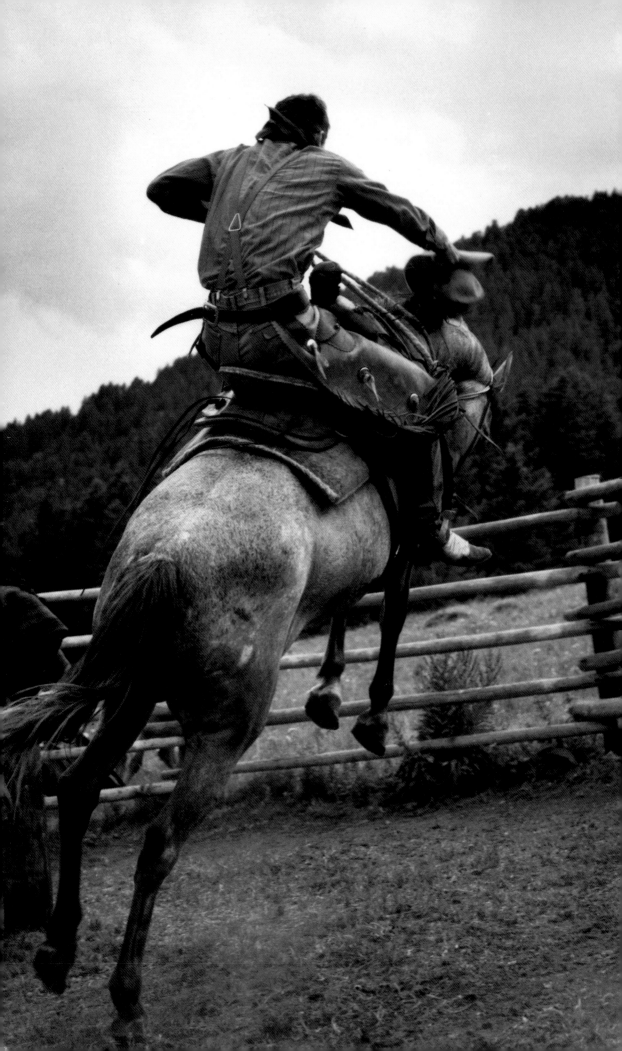

AWild-'n'-Woolly Western Episode from Rodeo Rider Afterlife in the Erroneous, Erogenous Twilight Zone
Or:
Another Zarzyski Poem That Goes All Downhill after Its Maniacal Title

Middle-aged and still 6-acres-crazy-18
in his mind, *imagine, if you will,*
a bucked-off-far-too-often roughstock rider,
call him *Rodeo-Flashback Rod,*
driving a lonely road to another nowhere
after another drab day, making wages,
wrangling dandies for some dude
ranch owned by who-knows-
who and . . . —*who IS this sonofaBITCH*—he rants,
pulling out in front of him
with a two-horse, honeymoon suite
color-coordinated two-tone gooseneck with Dodge
duelly barely doing 50,
chromed running boards worth more,
alone, than the cowboy ever pocketed
spurring ponies to the buzzer. In his Oldsmobile
land barge—vinyl roof sun-blistered and peeled,
looking like a patch of liverwort,
and liverwurst old paint-
job customized with body putty,
primer-grayed into a piebald, its hood
tick-tack-toed to bare metal by a colt
cheating at incisor solitaire, every grid
marked with winning Xs—imagine
this itchy cowboy wishing
Scotty would beam him the heck up
from his crossbred wreck
following the high-falutin
outfit through hilly Montana two-lane
of double-yellowed blue lane. Rambunctious to cruise
his usual hallucinating 88, all 4 windows cranked
down full (his answer to factory air
running on Max), he noses out,

then in—out, then in—until the hot wink
of sterling silver earring in the pickup's side mirror
hypnotizes him to tailing her
into The Big Sky twilight. His warp-10 mind
laser-beams in on a fantasy
brunette wearing nothing but one bucking horse rider
earring and black, fuchsia-inlaid Blucher
peewee boots, just enough to drive
him wild to make a pass
in curvy upthrust country. Side by side
with her, he glances just as she turns
away from him to smooch the French
poodle panting in her lap. That instant,
the passing gear kicking in
whiplashes what was once his lovely
erotic flock of monarch butterflies
aflutter in the Oldsmobile's rear window
back into Mastercard receipts
of his real West, the sunset into which—
imagine *why*, if you will—the cowboy rides off.

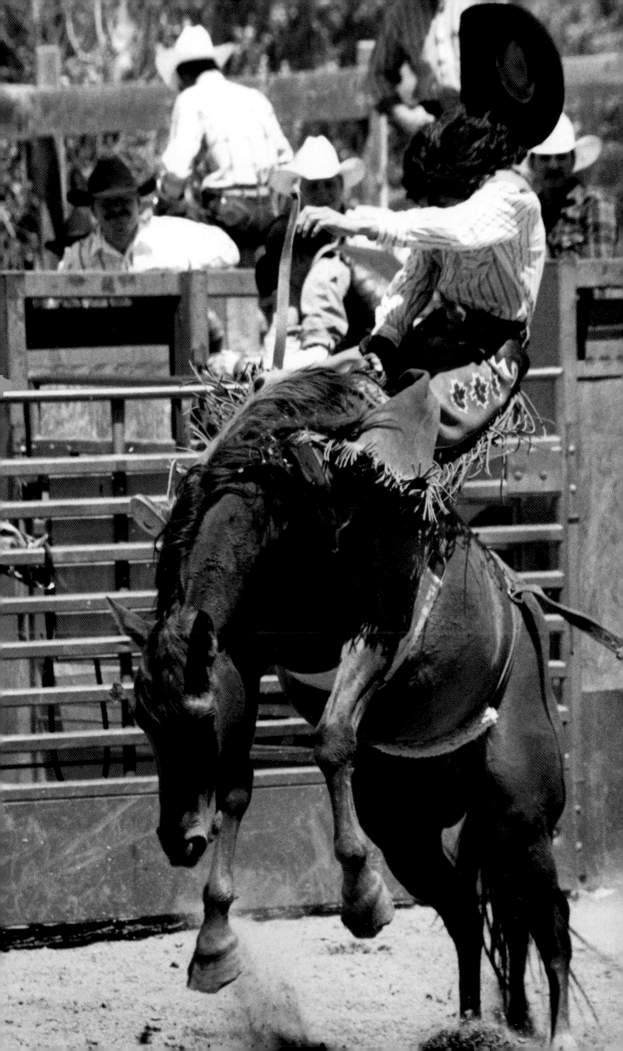

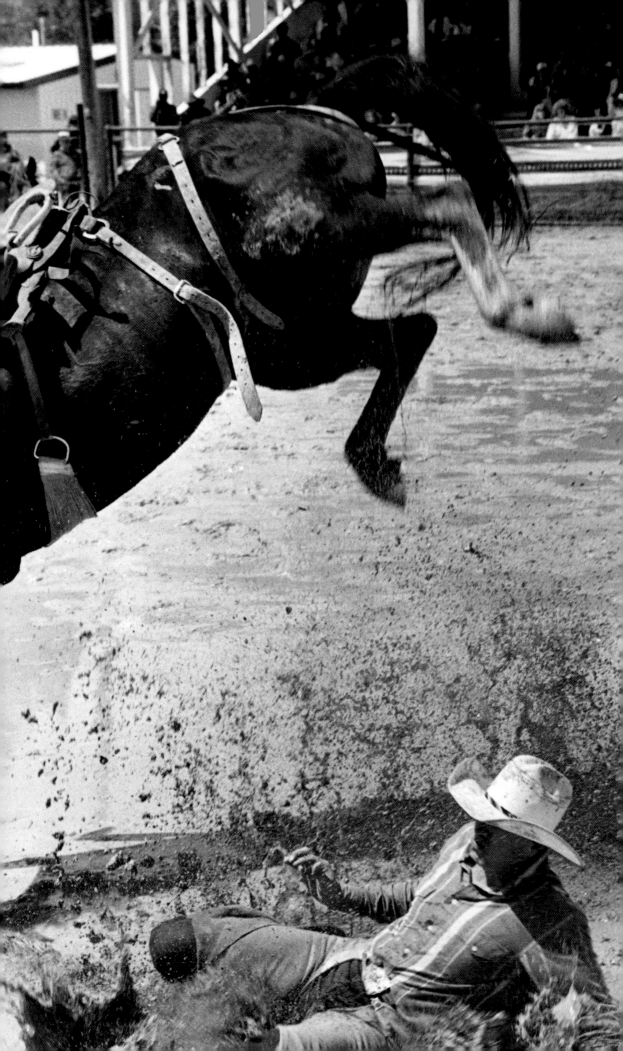

Photographic Credits